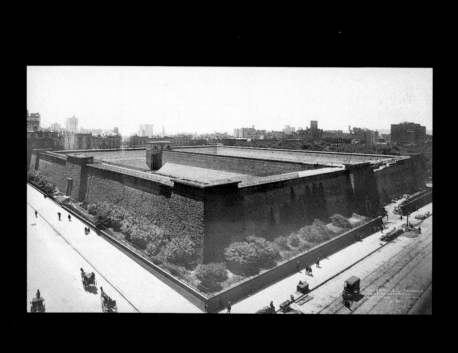

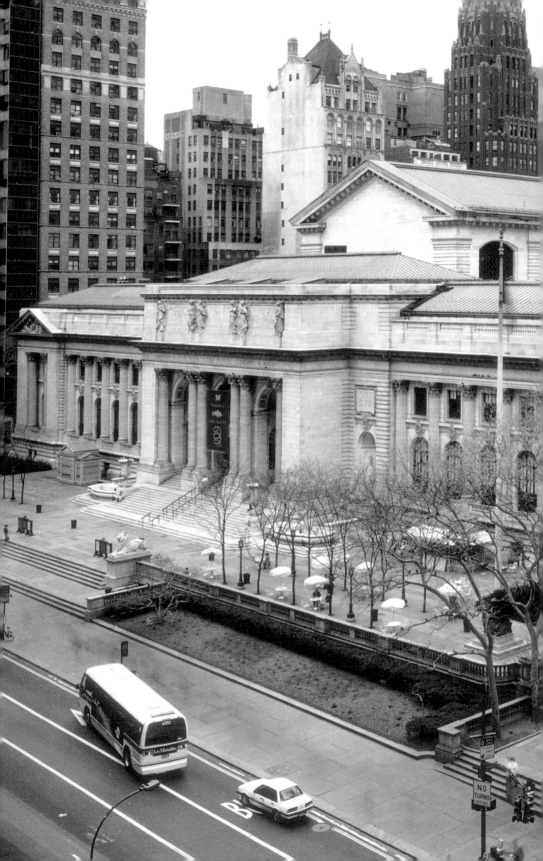

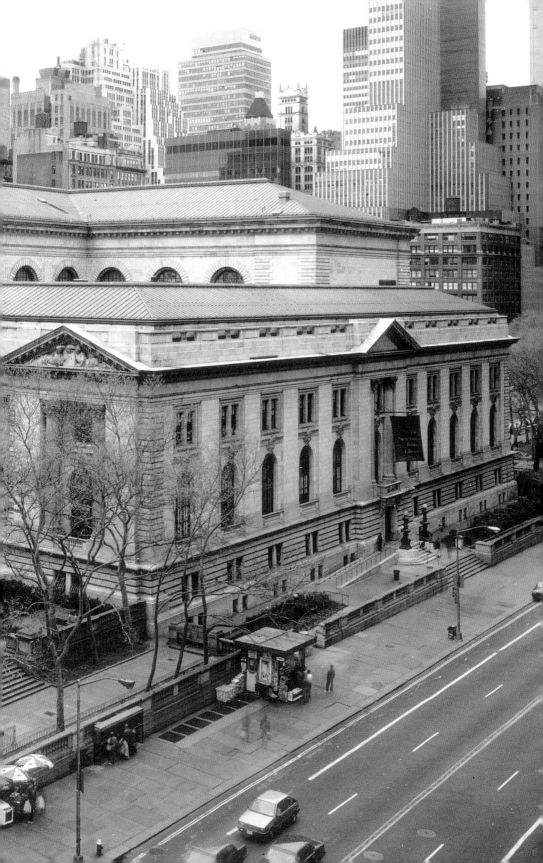

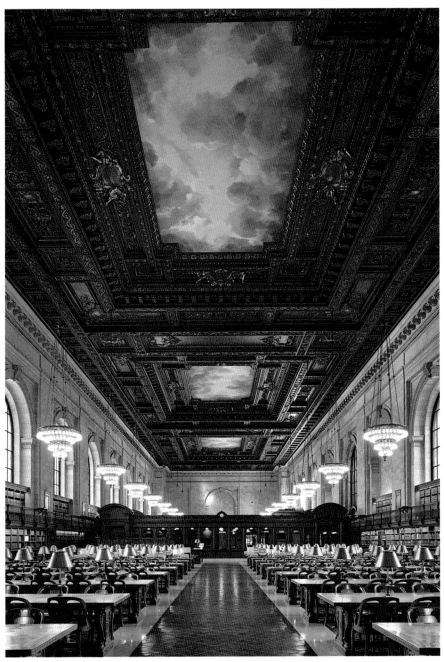

The Deborah, Jonathan F. P., Samuel Priest, and Adam Raphael Rose Main Reading Room in the Humanities and Social Sciences Library, The New York Public Library, 1998.

The
NEW YORK PUBLIC LIBRARY

A Universe of Knowledge

⚭

Phyllis Dain

The New York Public Library in association with
Scala Publishers, London

Author's Acknowledgments

A special word of thanks to Anne Skillion and Karen Van Westering, as well as gratitude to Ann Antoshak, Barbara Bergeron, and Ken Benson. Norman Dain and Bruce Dain were, as usual, good critics and wonderfully understanding and encouraging.

First published in 2000 by The New York Public Library, 476 Fifth Avenue, New York, New York 10018-2788, and Scala Publishers Limited, 143-149 Great Portland Street, London W1N 5FB
Distributed in the US and Canada by Antique Collectors' Club Limited, Market Street Industrial Park, Wappingers' Falls, NY 12590

The New York Public Library
Manager of Publications: Karen Van Westering
Senior Editor: Anne Skillion
Designer: Ann Antoshak
Editor: Barbara Bergeron
Picture Researcher: Ken Benson

Produced by Scala Publishers Limited
Printed and bound by Sfera International Srl, Italy

Library of Congress Cataloging-in-Publication Data
Dain, Phyllis.
 The New York Public Library : a universe of knowledge / by Phyllis Dain.
 p. cm.
 Includes bibliographical references and index.
 ISBN: 1-85759-234-4 (paperback; alk. paper)
 ISBN: 0-87104-450-1 (cloth; alk. paper)
 1. New York Public Library – History – 20th century. 2. Public libraries – New York (State) – New York – History – 20th century. I. Title.

Z733.N6 D35 2000
027.0747—DC21

 00-026758

www.nypl.org

ON THE FRONT COVER *Patience, one of Edward Clark Potter's famous lions, in front of the central building at Fifth Avenue and 42nd Street, 1998.*
ON THE BACK COVER *Library patrons in line at an Extension Division bookmobile in the Bronx, 1937.*
OPENING PAGES *Views from the northeast corner of Fifth Avenue and 42nd Street: the Croton Reservoir, by Irving Underhill, 1900; and the Library's central building, © Walter Dufresne, 1991.*

CONTENTS

❦

Preface, by Paul LeClerc
8

Prelude

1. "A Free Library for the Use of the People":
Predecessors and Founders
10

A Dream Fulfilled, 1913–1945

2. "Intellectual Hospitality":
The Research Collections
30

3. "The Sovereign Hope of Learning":
Neighborhood Library Service
60

Building Libraries in a New World, 1945–2000

4. "An Empowering Mechanism":
Modernization and Growth
84

5. "A Metaphor for an Ideal City":
Creating a 21st-century Library
112

Further Reading
139

Illustration Credits / Permissions
139

Index
142

PREFACE

L IBRARIES ARE the memory of humankind, irreplaceable
repositories of documents of human thought and action.
The New York Public Library is such a memory bank *par
excellence*, one of the great knowledge institutions of the world, its
myriad collections ranking with those of the British Library, the
Library of Congress, and the Bibliothèque nationale de France.

Libraries also serve as instruments of education and transmit-
ters of culture and information. Here, too, The New York Public
Library has been a national and world leader, offering to a vast
public popular neighborhood collections, information services,
and cultural programs as well as centralized, wide-ranging hold-
ings for research and study.

Virtually all these collections and services are freely available
to all comers. In fact, the Library has but one criterion for admis-
sion: curiosity. This easy accessibility, typical of American public
libraries but not necessarily of scholarly libraries, exemplifies the
American democratic ethos and belief in the individual's right to
information. To enter any one of The New York Public Library's
dozens of reading rooms – from the splendidly restored Rose
Main Reading Room in the Library's humanities research center
on Fifth Avenue, to the ultramodern Science, Industry and
Business Library a few blocks away, to a neighborhood branch in
the Bronx or Greenwich Village – and watch all sorts of people
going about their intellectual and artistic business is to see
democracy in action.

The New York Public Library is a peculiarly hybrid institu-
tion. It comprises simultaneously a set of scholarly research
collections and a network of community libraries, and its intel-
lectual and cultural range is both global and local, while singu-
larly attuned to New York City. That combination lends to
the Library an extraordinary richness. It is special also in being
historically a privately managed, nonprofit corporation with a
public mission, operating with both private and public financing
in a century-old, still evolving private-public partnership.
The research collections (for reference only, and organized as
The Research Libraries, with four major centers) resemble
the holdings of the great national and university libraries, and

A view of the rear facade of the Humanities and Social Sciences Library of The New York Public Library, looking up into the recently renovated Rose Main Reading Room.

the community circulating libraries (organized as The Branch Libraries) resemble classic American municipal libraries.

All these features, taken together, make The New York Public Library a unique and complex institution, wonderful to use but not always easy to grasp. One way to understand the Library is to consider its beginnings and subsequent evolution. It has been very much a creature of time and place, bearing the imprint of its origins but always, like any living organism, coping with struggles and problems while adapting to an ever-changing environment.

This book introduces the reader to that fascinating story.

PAUL LECLERC

President, The New York Public Library

CHAPTER I

"A Free Library
for the
Use of the People"

Predecessors and Founders

THE HISTORY of The New York Public Library spans the twentieth century. But its corporate name – The New York Public Library, Astor, Lenox and Tilden Foundations – reflects the earlier origins that very much determined its goals and character.

The Astor Library dated back to 1848, when New York real estate mogul John Jacob Astor, the richest American of his time, left the then munificent sum of $400,000 to establish the first privately endowed free public reference library in the United States. Joseph Green Cogswell, the first chief, built the Astor into a leading library, with a large, cosmopolitan collection used by scholars and literary lights of the day as well as by ordinary New Yorkers. Its Italianate building on Lafayette Place, an Astor family

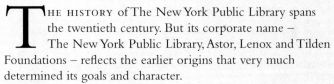

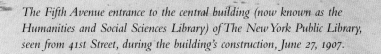

The Fifth Avenue entrance to the central building (now known as the Humanities and Social Sciences Library) of The New York Public Library, seen from 41st Street, during the building's construction, June 27, 1907.

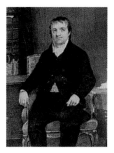

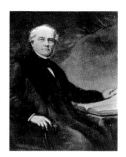

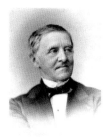

John Jacob Astor
(1763–1848).

James Lenox
(1800–1880).

Samuel J. Tilden
(1814–1886).

enclave just east of Greenwich Village, opened to the public in 1854 and immediately became a tourist attraction. But useful as the collection was and notwithstanding its being open without charge to all persons over the age of, first fourteen, and, later, sixteen, the library did not endear itself to the public. Not only did it keep limited opening hours (in part due to fear of fire in the days before electric light), its atmosphere was also rather off-putting and snobbish.

A generation later, the city got another endowed free reference library, the Lenox, on Fifth Avenue and 70th Street, the new, still bucolic uptown neighborhood of the city's very rich in their northward march up Manhattan's east side. In 1870, merchant and real estate owner James Lenox had incorporated his extensive personal collection as the Lenox Library. Initially consisting of rare books, manuscripts, Americana, and art works, the Lenox Library was run very much like a select museum.

[The Lenox Library] has now been in existence several years without being to the general public – for whose benefit it was nominally formed – of the slightest use.

unidentified newspaper clipping,
ca. 1881

By the 1890s, both the Astor and Lenox libraries had come upon hard financial times. They suffered from a bad press, the founders' families could not or would not continue to support them, and they could not easily attract outside funds. Furthermore, the dominant American model for libraries for the general public had become the central, tax-supported free public lending library, with neighborhood branches. For the support of advanced study and scholarship, the newly expanding universities were attracting the philanthropically inclined.

There were a good many libraries by then in New York City, which was essentially co-extensive with Manhattan Island until

1898, when a consolidated city comprising the five boroughs of Manhattan, Brooklyn, Queens, the Bronx, and Staten Island was formed. These libraries included privately run institutions that lent popular books for a subscription fee and newer ones, some with branches, that circulated books to local residents free of charge. But all of them together did not constitute a library system sufficient for the nation's largest city, and the free lending libraries, though receiving some municipal funds, were essentially charitable enterprises rather than community institutions. Efforts to establish a substantial public library in New York, which lacked a strong tradition of publicly funded cultural and educational institutions, had foundered.

Civic-minded New Yorkers lamented such a state of affairs in the nation's premier metropolis. Libraries were seen as emblems of civilized society and civic culture, visible proof that Americans, striving to emerge from intellectual and cultural colonialism, could match Europeans not only in industry and commerce but also in intellectual and cultural enterprises and in fostering a sense of history. The monumental central library buildings going up in the 1890s in New York's rival cities, Boston and Chicago, and in Washington, D.C., for the Library of Congress, signified civic and national power as well as the power of knowledge.

"Jan. 9, 1854. Astor Library Opened," a cartoon from Life, January 7, 1892. The Lenox Library was for many years even less approachable than the Astor Library, with holdings available only to a very few scholars. The New York Times called it "a select resort for bibliomaniacs."

The Library's founding director, Dr. John Shaw Billings, 1910. His pencil sketch for the general plan of a central building for the Library is at right.

Americans famously regarded education as a civic necessity in a free republic and as a pathway to success, and they conceived public libraries as educational institutions, especially at a time when most people had had only elementary schooling. The United States was furthermore a nation of immigrants who, established Americans believed, had to be assimilated into the dominant culture. Libraries could play this acculturating role.

Such considerations underlay the pro-library sentiment that finally transformed the library situation in New York. The catalyst was the last will and testament of Samuel J. Tilden, former governor of New York State and loser in the contested presidential election of 1876, who died in 1886. He directed that a Tilden Trust be formed with his considerable estate to establish a public library in New York City. But the astute and famous lawyer did not write an airtight will, and his relatives won a court challenge. In the end, the Trust received some money, but not enough for the proposed library. Much public and private discussion about the future of the Tilden Trust followed, along with negotiations involving most of the city's prominent libraries and cultural and academic institutions.

The final outcome was the consolidation on May 23, 1895 of the Tilden Trust and the Astor and Lenox libraries to form a new entity, The New York Public Library. This move, much celebrated in the press, promised to solve the problems of all

three institutions. The Astor and Lenox libraries would receive an infusion of funds for collections and staff, could cast off the aura of elitism and privatism, and could enter upon a new era of public usefulness and intellectual excellence. The Tilden Trust, for its part, found an acceptable means of carrying out Tilden's wishes. And New York was at last on the way to catching up with and surpassing other American cities in library resources and services.

Like its predecessors, The New York Public Library took the form of a private, nonprofit corporation, operating a reference library and governed by a self-perpetuating Board of Trustees. The board – whose most active members belonged to a new public-spirited, well-educated, culturally oriented elite – wanted to create a grand institution on a par with the Bibliothèque nationale de France and the British Museum Library, and one open fully and freely to the public. To fulfill their ambition, resources far beyond those of the new library would be needed.

Before anything else, though, The New York Public Library trustees had to "find our Panizzi" – a library director who could emulate in the modern age the great leader of the British Museum in the Victorian Age. And find him they did, in Dr. John Shaw Billings, a distinguished librarian and bibliographer, medical historian, statistician, consultant on hospital construction, and creator of the world-renowned U.S. Army Surgeon General's Library.

Billings immediately set out to integrate, organize, and refurbish the Astor and Lenox libraries, recruit a competent staff, set a collecting policy, and – very important in improving public usefulness – install electric lights and extend opening hours. He devised a unique, practical system – still in use – to arrange materials on the shelves, and work began on recording the holdings in a unified card catalog.

Billings's broad, catholic approach to collecting guided the development of the research collections for years to come. An omnivorous reader, an active man of affairs, and a believer in the value of information of all kinds, he conceived the Library as a systematically created repository of documents useful for modern life as well as for the pursuit of scholarship and science, and as constituting a comprehensive historical record. The Library would attempt to acquire virtually everything in certain areas (such as American history, a Lenox Library specialty) and to maintain comprehensive collections in other fields (except theology, education, law, medicine, and the life sciences, for which substantial libraries existed elsewhere in the city). The focus would be on works suitable or potentially suitable for research.

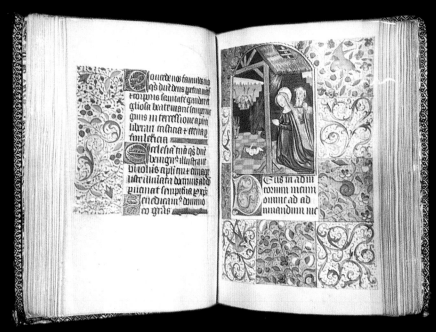

BOOK OF HOURS. FRANCE, 15TH CENTURY.

LECTIONARIUM EVANGELIORUM.
CORVEY, NORTHERN GERMANY, CA. 970.

LECTIONARIUM EVANGELIORUM
[TOWNELEY LECTIONARY]. ROME, CA. 1550–60.

GEORGE WASHINGTON'S FAREWELL ADDRESS.
AUTOGRAPH MANUSCRIPT, 1796.

BIBLE. MAINZ: JOHANN GUTENBERG, CA. 1455.

The Rare Books Division and the Manuscripts and Archives Division

With the Library's consolidation, treasures from the Astor and Lenox libraries came into the permanent collections of The New York Public Library, forming the bases for today's Rare Books and Manuscripts divisions. Among these were rare early printed books and manuscripts, including such glories as the great landmark of the printed word, the Gutenberg Bible (the first brought to the United States); the final 32-page draft of George Washington's Farewell Address; and superb illuminated manuscripts, including this fifteenth-century French Book of Hours and the sixteenth-century Towneley Lectionary (all from the Lenox Library), and a tenth-century Carolingian *Lectionarium Evangeliorum* (from the Astor Library), shown on these pages.

Today, these divisions continue to collect both modern and historical rarities and manuscripts of significant cultural value. Recent additions to the Rare Books Division include the Wheeler Collection on the history of magnetics and telegraphy and the Martin J. Gross Collection of Voltaire and his contemporaries. Manuscripts and Archives has acquired many distinguished collections of individual and family papers, as well as publishers' and other organizational archives: for example, the papers of Robert Moses and H. L. Mencken reside there, as do the archives of *The New Yorker* magazine, Farrar, Straus & Giroux, and the Gay Men's Health Crisis.

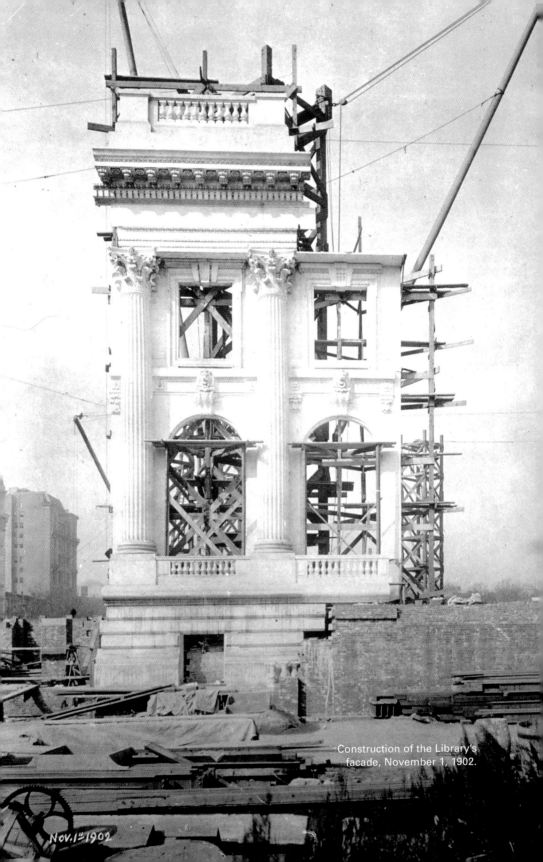

Construction of the Library's facade, November 1, 1902.

Nov. 1 st 1902

To house the collections, current and future, and to accommodate users, the Library needed a new, central building. Here the Library's public-private partnership would begin. In 1897, the Board of Trustees formally asked the city to supply a site, construct and equip a building, and maintain the building and grounds. The proposed city-owned site was "Reservoir Square," occupied by the obsolete, gloomy, huge Croton Reservoir, 40 feet high, covering an area 455 by 420 feet, on the west side of Fifth Avenue between 40th and 42nd Streets; behind it was Bryant Park, a green oasis in an area filling up with commercial buildings. The location could not have been better: at the central crossroads of Manhattan, easily reached by public transportation and near Grand Central Terminal and the planned Pennsylvania Station. For the busy, large, influential, inviting, popular institution that The New York Public Library's trustees envisioned, a library on the reservoir, "dignified, ample in size, visible from all sides, with uninterrupted light, free from all danger of fire, in no respect encroaching upon the existing Bryant Park," would be "an ornament to the City."

Municipal officials were persuaded to meet the Library's request, and the lease and agreement between the city and the Library, dated December 8, 1897, represented the first time that New York City assumed responsibility for library support on a large scale, albeit only for the building and its maintenance. In return, the Library committed itself to operate a "public library and reading room" free to the public and open every weekday for a minimum of twelve hours, until at least 9 p.m., and Sundays from 1 to 9 p.m. The Library would also undertake to operate in the building a "free circulating branch" with books for home use, open during the day on Sundays and in the evenings on all other days. These provisions, plus the role of the city, affirmed the democratic character of the Library, and the agreement drew strong public approval.

The Library had already moved ahead to develop architectural plans, based on a concept worked out by Billings. Intensely practical, he wanted a functional building that, unlike many other American libraries, would be designed for efficient library operation and the convenience of the public. The trustees appreciated this, but they also wanted a beautiful and impressive structure.

The final design emerged from two competitions entered by some of the city's most prominent architectural firms. The winner was Carrère & Hastings, a firm that had designed fine private residences and hotels but nothing yet on the scale of the Public

Library. That commission was an important prize for the still young John Merven Carrère and Thomas Hastings, graduates of the École des Beaux Arts in Paris and former draftsmen in the office of the reigning American architects, McKim, Mead & White.

Work on razing the reservoir started in 1899, and from then to opening day the project took twelve years. Progress was hampered by, among other things, political squabbles, contractual problems, labor disputes, and the task of quarrying and transporting the 530,000 cubic feet of Vermont marble for the exterior and part of the interior. And the building was complicated and elaborate. The furniture and fittings, in fine woods and metalwork, were all custom made, their design closely supervised or created by Carrère and Hastings themselves. Their fastidious attention to detail and workmanship can be seen in, for example, the carved ceilings and tables, intricately worked bronze chandeliers and lampposts and doors, marble floors and doorways, decorative water fountains, and ornate door handles. A dozen varieties of marble, domestic and imported, were used in the interior, and marble figures by distinguished sculptors embellished the front facade with its classical portico and great pediment.

The cost came to the then immense sum of $9 million, well over $2 million more than the new Library of Congress, which bore no particular architect's signature. But the result in New York, it was generally agreed, was a grand, beautiful, and workable civic monument well worth the money. The architects had succeeded in combining the practical, the aesthetic, and the monumental; and the majestic facade, spacious halls, and exquisite interior fixtures and materials expressed their artistic ideals and sense of grandeur. The Library, to which they had devoted years of work and concern, was Carrère and Hastings's masterpiece.

The interior plan expressed a logical progression upward that was related to use, users, and collections. The more popular collections – the circulation branch, a children's library, and the newspaper room – were on the street level, easily reached through an entrance on 42nd Street. The first floor, with a grand terraced entrance on Fifth Avenue, had exhibition halls, current periodicals, and the technology and patent collections. Situated on the second floor were the science, economics and public affairs, and public documents rooms, plus other special reading rooms. The third and top floor had the most unusual feature – a vast quarter-acre main reading room, accommodating more than seven hundred users, and standing almost 52 feet high, atop the steel book stacks that rose up from ground level at the rear

*Craftsmen at work in the plaster carving workshop in the unfinished
building, June 10, 1902.*

of the building. As Billings had planned, here, in what one
writer called "one of the most superb rooms in the world,"
readers could consult materials from the general collection and
work comfortably, with maximum air and light, far above the
clatter and smells of vehicles and the noise of crowds on the
busy streets below, and with minimum distraction from sightseers.
The top floor also contained the card catalog, information desk,
picture galleries, and rooms for special collections – American
history, genealogy, maps, prints, art and architecture, and rare
books and manuscripts.

The formal dedication, with invited guests only, took place
on May 23, 1911, sixteen years to the day after the Library's
founding. President of the United States William Howard Taft,
the governor of New York State, the mayor of the city, and other
officials spoke at the ceremonies. Newspapers and periodicals, the
library press, and architectural journals ran extensive, laudatory

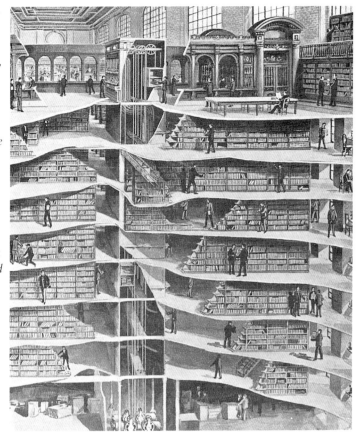

Although the new Library building was classical in style and structure, the architects did use some modern materials, such as steel and cast iron, as well as the latest technologies – elevators, book lifts, pneumatic tubes, and electric lighting. The May 27, 1911, issue of Scientific American *featured the innovative delivery system illustrated in this cross-section of the stacks.*

articles that called the building a "modern temple of education" that was to New York "what the cathedral of old was to the cities of olden times." The splendid interior drew special praise: it was "beyond criticism, superbly rich as befits the most important monumental building in America's most important city."

The general public responded by coming in droves not only to see the building but to use the library, which opened to the public the day after the dedication. A young Russian émigré received the first book delivered to a reader, a Russian-language study of Nietzsche and Tolstoy; both reader and book symbolized the changing culture and new clienteles the Library would serve.

The building immediately became a New York City land-mark. Years later, in 1967, when New Yorkers began seriously to consider their architectural heritage, the new New York City Landmarks Preservation Commission cited the central library

as an official landmark, a "masterpiece of the Beaux-Arts style of architecture, . . . a magnificent civic monument, . . . a joyous creation." Sculptor Edward Clark Potter's two reclining stone lions guarding the Fifth Avenue entrance, although deemed too benign by some early critics, are familiar New York emblems, adopted by the public and fondly dubbed Lady Astor and Lord Lenox or Patience and Fortitude.

On the whole the design worked well for both users and staff. The major problem became not so much the building itself but acute shortages of space for books and people. Wise and prescient as Billings and the trustees were, and as aware as they were of the need to provide for growth, they did not imagine how quickly collections and users would tax the space, which seemed at the outset so huge.

BACK IN 1899, after Billings and the trustees had accomplished their initial goal of acquiring a home for the reference collections, the other crucial library need in the city – a coordinated citywide circulating library network – claimed their attention. Out of this concern would come The New York Public Library's second major public-private partnership and its venture into popular library service on a grand scale. Public libraries in New York would be fully transformed from charitable enterprises to essential public services.

The first important step in that direction came early in 1901. The New York Free Circulating Library, the largest of the city's independent lending libraries, merged into The New York Public Library, "in the confident hope," the final report of the Free Circulating Library said, "that the reading public will be better served when all our existing branch libraries, and such other branches as may be added, are under the wise supervision and control of one large central corporation." The branch library system of The New York Public Library (called the Circulation Department to 1966, and afterwards The Branch Libraries) was born. Although a constituent part of the Library, accountable to the director and the trustees, it operated quite distinctly from the research collections (called the Reference Department to 1966, and afterwards The Research Libraries).

With the new consolidation, The New York Public Library became an irresistible magnet for other circulating libraries, especially when the city threatened to cut off their funding. But if they also consolidated, where would the money come from to replace

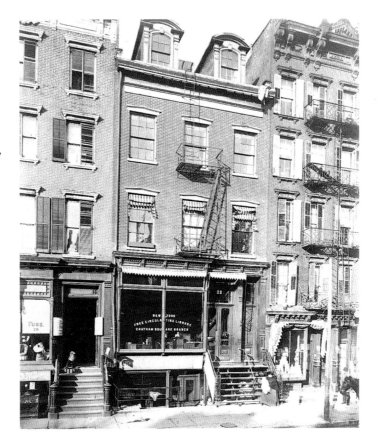

their crowded, shabby, unsatisfactory buildings and create a library
system ranging over an expanding city? City subsidies applied to
operating funds only, and The New York Public Library's endow-
ment pertained almost exclusively to the research collections.

Salvation came from steel magnate Andrew Carnegie, just
retired from business and embarking on the famous massive phil-
anthropy based on his "gospel of wealth." He believed that the
surplus of great fortunes, earned through superior ability, should
be disbursed for the public good and thus redress the imbalances
of modern industrial life and immunize against radicalism. He
proposed to donate funds for library buildings, providing that
municipalities supply the sites and agree to maintain the libraries
at a level of at least 10 percent of his gift. New York City was the
first beneficiary of his wholesale library philanthropy, which by
1917 amounted to more than $56 million for 2,509 public library
buildings in the English-speaking world.

Soon after the Free Circulating Library merger, Carnegie offered, with his usual conditions, $5.2 million to build a network of branches in all five boroughs of New York. The response was overwhelmingly positive, even ecstatic. Decision-makers in New York, fortified by public opinion, took prompt action to accept the gift and ensure that its implementation would be in the hands of The New York Public Library and other appropriate library organizations. Here a crucial decision had to be made. The boroughs of Brooklyn and Queens, before 1898 separate from New York City, had their own public libraries. Should the newly formed Brooklyn Public Library and Queens Borough Public Library be absorbed into The New York Public Library? The final answer, which involved politics and local pride, was no. The city would have a unique triad of separate library organizations,

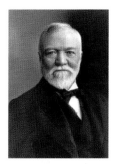

Andrew Carnegie (1835–1919), whose philanthropy ultimately helped build branch library networks in New York's five boroughs, thirty-nine of them under the aegis of The New York Public Library.

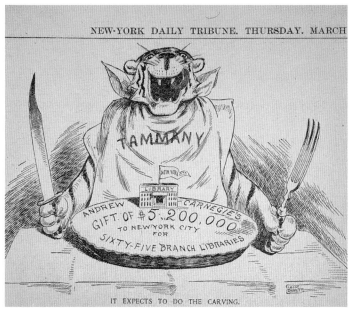

NEW-YORK DAILY TRIBUNE. THURSDAY. MARCH

IT EXPECTS TO DO THE CARVING.

"It Expects to Do the Carving," cartoon by Leon Barritt in the New York Daily Tribune, *Thursday, March 21, 1901. Andrew Carnegie's offer of money to build libraries for New York drew near-unanimous applause from all quarters, including politicians of all stripes. Among them were the leaders of Tammany Hall, the notorious Democratic Party machine, whose motives were questioned by skeptics like this cartoonist. In fact, the public libraries were given control over the projects, to which no taint of corruption was ever attached.*

The Branch Libraries: Architectural Landmarks

Architectural details from the facades of two Manhattan branches, the 115th
Street Branch Library in Harlem (top) and the Ottendorfer Branch Library on
Second Avenue in the East Village (bottom left). The terracotta trim of the latter,
with its owls and globes, suggests, as a writer for *The New Yorker* observed,
"the deeper perceptions and wider horizons that may await readers inside."
The plaque (bottom right) at the Yorkville Branch Library, on Manhattan's Upper
East Side, commemorates the generosity of Andrew Carnegie. The four libraries
pictured on these pages are official New York City landmarks.

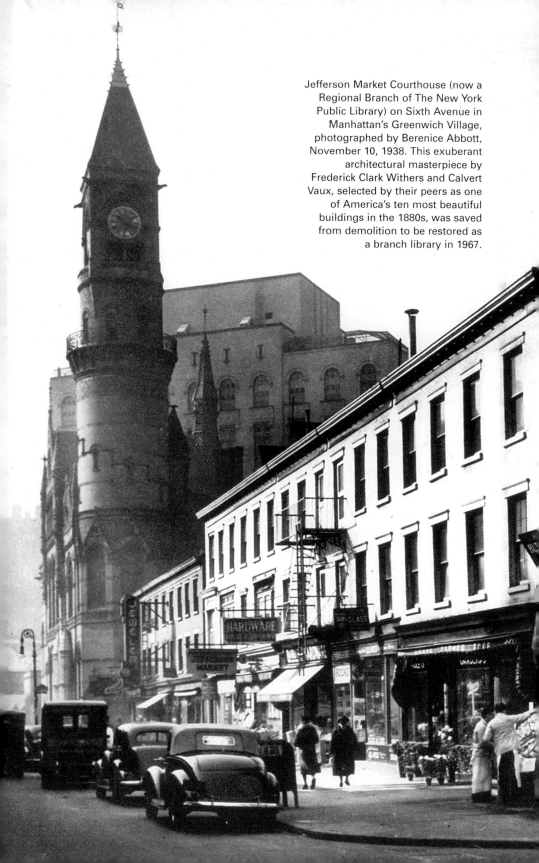

Jefferson Market Courthouse (now a Regional Branch of The New York Public Library) on Sixth Avenue in Manhattan's Greenwich Village, photographed by Berenice Abbott, November 10, 1938. This exuberant architectural masterpiece by Frederick Clark Withers and Calvert Vaux, selected by their peers as one of America's ten most beautiful buildings in the 1880s, was saved from demolition to be restored as a branch library in 1967.

with The New York Public Library taking responsibility for Manhattan, the Bronx, and Staten Island.

The city contracted with The New York Public Library in 1901 to acquire sites for the Carnegie branches and support them thereafter, marking the first time that the municipality pledged perpetual funding for circulating libraries. The Library would have control over their construction and operation and would maintain liberal opening hours. In 1902, based on an informal understanding, the Library's board was enlarged to include three ex-officio members representing the city; the trustees also agreed to elect several regular trustees who would be more representative of the city's heavily Catholic and Jewish population than the existing Protestant and highly elite board.

As soon as the contract was settled, the Library began to investigate branch sites and devise building plans. Under its aegis, thirty-nine Carnegie buildings were constructed within walking distance of residents in locations selected on the basis of population density. The first library built with Carnegie funds, the Yorkville Branch on East 70th Street, opened in 1902; branch construction went on for the next dozen years, with two final branches built in the 1920s. Leading architects served as consultants and designers; several branches were later named New York City landmarks. For their time and for their sites (some quite narrow ones in narrow Manhattan, where building had to be upward), all the branches, which had reading rooms for both adults and children, were well designed, if not in the more open and inviting mode that a future generation would favor.

The Carnegie gift stimulated the consolidation with The New York Public Library of most of the free lending libraries in the city. The carrot of Carnegie branches and the stick of withdrawal of municipal funds finally persuaded them to surrender their individuality and autonomy for "the larger good," as one of their trustees said. In all, eleven such institutions officially joined The New York Public Library, in a process that ended in 1906; two others informally ceded their collections, a few continued on without city aid, and others died out.

The first chief of branches, Arthur E. Bostwick, formerly head of the Free Circulating Library and then of the new Brooklyn Public Library, began the long process of molding the various libraries under his supervision into a unified, interconnected library system. In time the origins of the branch system grew obscure, but some of its outstanding qualities and traditions derived from its predecessors. Probably the strongest heritage was the sense of

community, the attention to neighborhood characteristics and close acquaintance with the people. Linked to this tradition was a certain leeway given to branch librarians to shape collections and services to meet perceived community needs.

Through all the consolidations and changes, the construction and opening of new branches and the closing of old ones constantly went on. The pace was so fast that the librarians felt themselves, Bostwick recalled, "rushing down the toboggan slide from whose top we had been gazing for so long."

THE LIBRARY had grown phenomenally. Billings's death in March 1913 marked the end of an era in which he had, working with trustees and staff, virtually accomplished miracles. The central building was finished, and the Astor and Lenox libraries were integrated and under one roof. (The old Lenox building was sold and replaced by the present Frick Collection, designed by Hastings; the Library also sold the Astor Library, which in the 1960s was restored as the New York Shakespeare Festival's Public Theater.) The staff had grown from fewer than a hundred at the beginning to more than a thousand in 1913. The research collections more than doubled, from nearly 500,000 in 1896 to more than a million in 1913; the number of readers tripled; and the volumes used more than quadrupled. The branch library system now comprised forty-four branches, plus Central Circulation and Central Children's rooms; the branches' total holdings more than quadrupled; and books lent reached a record high of eight million. The New York Public Library led the world in circulation of books for home use and had risen to the front rank among research libraries. It was truly, as an inscription in the central building proclaimed, "a free library for the use of the people."

I have before me the report of the New York Public Library for 1911.

That year . . . there were 246,950 readers using the reading-room and they took out 911,891 books. . . . The New York Public Library has forty-two branches and will soon have a forty-third. . . . The aim that is constantly pursued is to have a branch of the Public Library within three-quarters of a verst, i.e., within ten minutes' walk of the house of every inhabitant, the branch library being the centre of all kinds of institutions and establishments for public education.

. . . The New York Public Library has opened a special, central, reading-room for children, and similar institutions are gradually being opened at all branches. The librarians do everything for the children's convenience and answer their questions. . . .

Such is the way things are done in New York. And in Russia?

V. I. LENIN
Rabochaya Pravda, no. 5 (July 18, 1913), in his Collected Works, vol. 19 (1963), pp. 277–79

CHAPTER 2

"INTELLECTUAL HOSPITALITY"

The Research Collections

A NEW GENERATION of leaders and librarians, building on the foundations laid by Billings and the first trustees, continued the formative process that set the basic character of the Library for years to come. From 1913 through the 1920s, and continuing into the hard times of the 1930s, the Library evolved into a complex combination of popular scholarly academy, information center, and neighborhood lyceum. Sui generis, it was a modern New World invention, a dynamic knowledge institution of the twentieth century. Just as New York City consolidated in those years its position as the nation's financial, corporate, and cultural capital and as a dynamic world capital, but was not the capital of the United States, so The New York Public Library, which was not the national library, stepped firmly into the ranks of the world's premier libraries and served in effect as a second national library, complementary, as it were, to the Library of Congress. The dream of the founders to create a peer of the British Museum and the Bibliothèque nationale de France was fulfilled.

Three examples of dime novels from the Rare Books Division, including an Italian edition of a Buffalo Bill tale.

The research collections were amassed by librarians committed to what they saw as the modern, open-ended, limitless, objective, scientific search for knowledge. They tried therefore to get "everything." They knew they could not really do that, but their striving for universality, they believed, would – and did – yield a grand array of documentary and intellectual resources for an extraordinary variety of scholarly work, in their own time and afterwards. Their ideal still has urgency for librarians – the preservation as far as possible of the myriad documents of human society.

Not being affiliated with a university, nor existing under government auspices, The New York Public Library had the independence to range far and wide in its research collections, without ideological or pedagogical considerations. The librarians had the advantage of working in an autonomous institution in a liberal city and with an enlightened board of trustees composed of some of the most powerful people in the country. The Library's constituency was the general public; its intellectual obligation was to the preservation and advancement of knowledge. And librarians and trustees were acutely conscious of being in the largest city in the country, and at the center of things – communications, commerce, finance, art, music, theater, design – and of being the only library there of very broad scope and open to the public. This heightened their sense of responsibility to create a coherent cumulative historical record of human culture. In doing so, they would serve the interests of their exceedingly heterogeneous clientele, which they would also serve through certain special collections and emphases that gave the Library much of its New York personality.

> **We serve the crackpot who may be tomorrow's genius as well as the genius for whose productions the world may not be ready. . . . A great library is a living thing with power to support a truth or destroy a fallacy.**
>
> EDWARD G. FREEHAFER
> *Director of The New York Public Library, 1957*

AFTER BILLINGS's death in 1913, his successor, the clever, strong-minded, highly principled Edwin Hatfield Anderson, who in Pittsburgh in the 1890s had created a notable public library collection, worked with the chief of the research libraries, Harry Miller Lydenberg, to affirm and amplify Billings's collecting policy. Lydenberg, Billings's protégé and a master bookman who in 1934 succeeded Anderson as Director, oversaw for more than three decades the consistent execution of that policy.

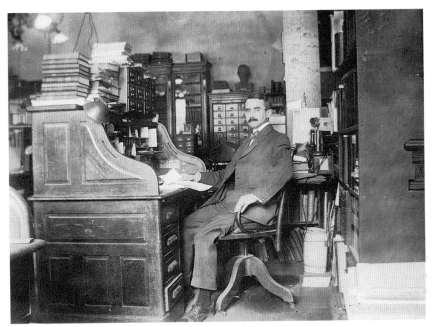

Harry Miller Lydenberg, guiding spirit of the research libraries and one of the great librarians of his day, at the Astor Library, 1910.

Driving the selection of materials was the principle of "intellectual hospitality," as Anderson put it. "None of us here would think of allowing his own personal opinions to influence the selection of books. . . . practically everything is grist that comes to our mill." Conservative in politics, liberal in collecting, he and Lydenberg, together with a remarkably dedicated and expert staff, set out to build a documentary record of the life and knowledge of the times, good or bad, like it or not. They had a historical sensibility and a commitment to the creation of new knowledge and the preservation of the old. They believed in the necessity of organized knowledge in modern society, the importance of the life of the mind, the civilizing role of libraries and free access to them, and the civic need for an informed citizenry in a democracy.

They also appreciated the multifaceted nature of knowledge and understood that future tastes and interests could not be predicted. So they acquired the obscure and unorthodox as well as the acclaimed and conventional, and in a variety of formats. And through their concern for community interests as well as their documentation instincts, the collections were multicultural long before the late twentieth-century vogue.

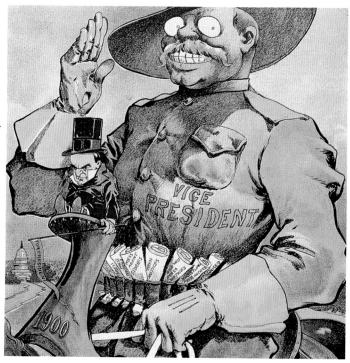

This cosmopolitan stance informed the effort to acquire material on all sides of controversial questions. "If the devil himself wrote a book, we'd want it in the library," Anderson said. The liberalism, which the Library had periodically to defend, extended to the branches, although they collected much more selectively than the research libraries, and it long predated the library profession's first official expression of intellectual freedom, the American Library Association's anti-censorship "Bill of Rights" of 1939.

The research libraries' overall approach was global, extraordinarily so for the time. In holdings of foreign publications the Library stood among the vanguard of American libraries. Although in the early twentieth century the United States was emerging as a major world power, many Americans remained provincial and ethnocentric; academic study and research concentrated on Western European society and culture. With notable exceptions – the Library of Congress and several university libraries, along with The New York Public Library – American libraries tended to neglect non-Western European subjects and materials in non-Roman-alphabet languages, gaps that the advent of World War I and the Russian Revolution made quite evident.

BOOKS WANTED FOR OUR MEN IN CAMP AND [...]

A World War I book drive for soldiers serving in France, April 4, 1918, on the front steps of the central building.

Avrahm Yarmolinsky, chief of the Slavonic Division (now the Slavic and Baltic Division), in Moscow in 1924, during a buying trip to Bolshevik Russia.

The New York Public Library's librarians tried to get whatever they could on the war, from all sides and representing "every phase of opinion from the wildest to the most radical." (Many years later, historian Barbara Tuchman was able to do practically all the research for her classic study of the war's outbreak, *The Guns of August*, at the Library.) Once the United States entered the war in 1917, anti-German and then anti-Bolshevik hysteria provoked widespread censorship, in which most public libraries acquiesced. But not The New York Public Library. True, security personnel might keep an eye on readers calling for "seditious" materials and on employees considered "alien enemies," but the integrity of the collections was preserved.

The solidly anti-Bolshevik Library board even sent Lydenberg and the poet and scholar Avrahm Yarmolinsky, chief of the Slavonic Division, to Bolshevik Russia in 1923–24 as part of a larger trip by Lydenberg to postwar Europe to acquire materials and reestablish relations with dealers and other sources. Trustees and librarians understood the value of documenting what was clearly a new era, and of doing so on the spot. Lydenberg would put up with bureaucracy, cold, homesickness, and Bolshevism for the Library's sake. Above all, he was a keen collector. Between visits to librarians and officials, he would dutifully go with Yarmolinsky and his wife, the poet Babette Deutsch, to the

crowded and impassioned poetry readings that inspired Russian youth in those optimistic pre-Stalinist days. And then he would buy the poetry.

The historical sense led Lydenberg to develop collections of what he considered among the most precious items in the Library – the pamphlets, many of them unique copies, often on unconventional subjects, and issued outside the regular book trade. Current events and trends – in politics, economics, science and technology, popular culture, as well as wars and revolutions – were assiduously followed. The "new marvel" of radio and the popularity of motion pictures stirred efforts at the Library to document their development and serve people involved in all the various aspects of the communications industries centered in New York.

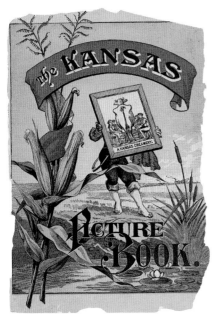

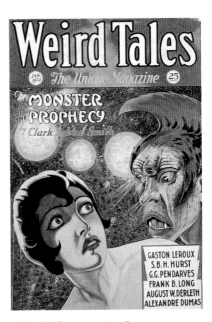

The Kansas Picture Book, *1883. In 1923, Lydenberg sent a representative out West to buy "ephemeral material relating to the westward movement in this country," material not readily available and "not systematically collected by any of the eastern libraries." Today such holdings are among the lesser-known treasures of the Library.*

Weird Tales *magazine, January 1932. In the 1910s and 20s, the Library began to collect materials that, as one librarian put it, "might be called trash" and that were ignored by most libraries but had research value as expressions of popular culture – joke, detective, screen, and adventure magazines and the like.*

Early on, policy dictated that rare, costly works per se would not have first priority in purchasing. They were not precluded, however, and the rare and unique book and manuscript collections, much of them acquired through gifts, are extensive and very important. Several of the special divisions owe their origin to gifts, some of them quite splendid, as does much of the material that contributes to the Library's great strengths in English and American literature, American history, and the performing arts, as well as the papers of prominent persons, families, and organizations. The librarians were also open to all manner of donations to the general collections that would bring in unusual materials of cultural or historical interest, like the Beale shorthand collection, the Beadle Dime Novels, the Spalding and Swales collections on baseball, and menus and cookbooks.

BILLINGS'S SENSE of the direction of modern society and his scientific interests had informed his organization of separate, important divisions for science and technology and, for the new social sciences and public policy issues, the Economics Division. He had also established the first department of public

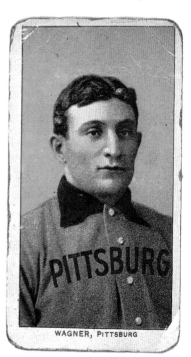

The extremely rare Honus Wagner baseball card, from the Arents Tobacco Collection. Distributed with Sweet Caporal cigarettes around 1910, the card was pulled from circulation at Wagner's request, because he didn't want children to buy tobacco in order to get his card.

WAGNER, PITTSBURG

A plate from an early nineteenth-century Viennese volume on decorative ornamentation, from the Art and Architecture division's collection of interior design literature, one of the most significant in the United States.

documents – domestic and foreign – in a large library, a unit later merged into the Economics Division.

The modernity extended to the outstanding holdings in language and literature and the arts, which encompassed the work of the new writers, artists, and critics that signaled America's cultural coming of age. Most of these men and women were living in New York in the 1920s, drawn from the boondocks to the free-wheeling, exciting, tolerant, fast-paced city. The Library acquired, usually when first issued, the works of the new literati and graphic artists plus those of political and social activists and modernist intellectuals, put out by obscure or new publishers as well as established ones. These included controversial books often

The Spencer Collection

A spectacular early gift arrived through the will of wealthy book collector William Augustus Spencer, who went down with the *Titanic* in 1912. He left to the Library his collection of 232 illustrated books in fine bindings and the original artwork for some of the illustrations, plus half the residue of his estate, to be used to buy the finest illustrated, handsomely bound books available anywhere, and thereby create "a collection representative of the arts of illustration and bookbinding." Since then, curators have assembled in the Spencer Collection a magnificent array of some 10,000 specimens of the art of the book worldwide.

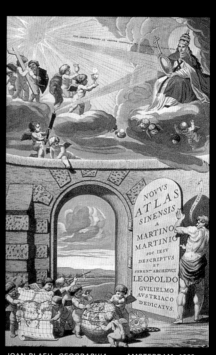

JOAN BLAEU, *GEOGRAPHIA*. . . . AMSTERDAM, 1662.

SAMGRAHANĪSŪTRA. WATERCOLOR DRAWING, CAMBAY, INDIA, 1604.

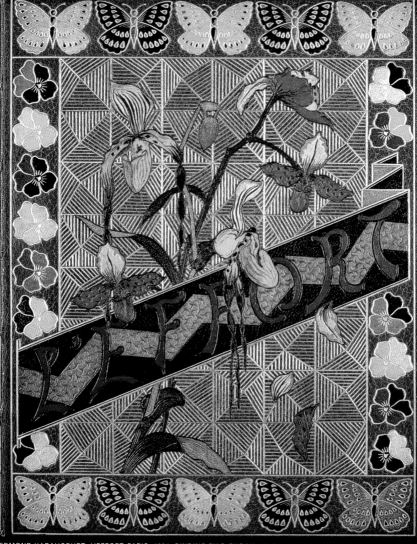

EDMOND HARAUCOURT, *L'EFFORT*. PARIS, 1894. BINDING BY P. RUBAN, 1897.

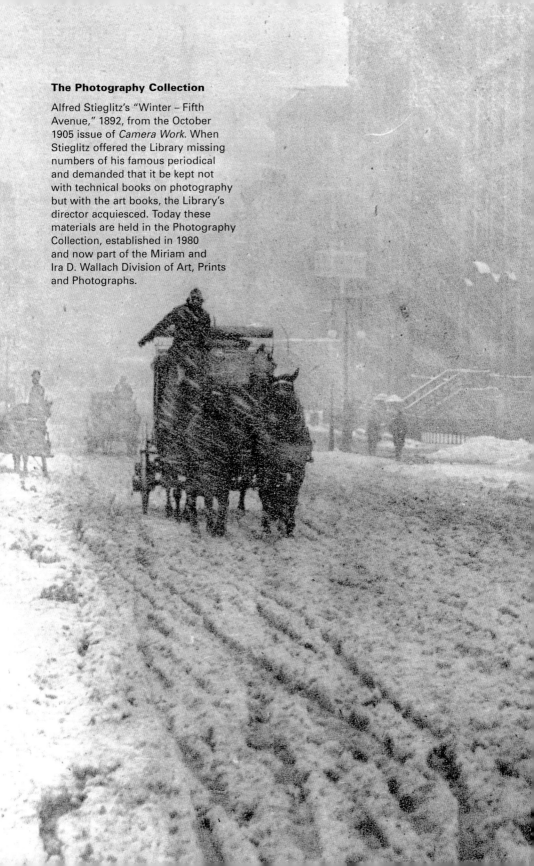

The Photography Collection

Alfred Stieglitz's "Winter – Fifth Avenue," 1892, from the October 1905 issue of *Camera Work*. When Stieglitz offered the Library missing numbers of his famous periodical and demanded that it be kept not with technical books on photography but with the art books, the Library's director acquiesced. Today these materials are held in the Photography Collection, established in 1980 and now part of the Miriam and Ira D. Wallach Division of Art, Prints and Photographs.

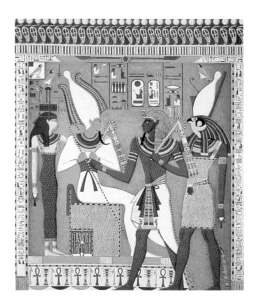

A hand-colored lithograph depicting murals from the ancient tomb of Seti I in the Valley of the Kings in Egypt, from Ippolito Rosellini's I Monumenti dell'Egitto e della Nubia *(Pisa, 1832–44), a treasure of the Oriental Division.*

censored in other public libraries and runs of practically every offbeat, radical early twentieth-century periodical and literary "little magazine" (along with thousands of periodicals and newspapers on all subjects).

In recognition of the city's position as the American mecca for the performing arts – home of the Metropolitan Opera, Carnegie Hall, Tin Pan Alley, and Broadway – the Library began in 1915 to give systematic attention to music, in which there were even by the 1920s few public collections. The result at The New York Public Library was a premier collection of music and musicology, second in the United States only to that of the Library of Congress (and first in volume of use). Holdings in American music, for a long time not widely respected in America, grew in the 1930s under composer John Tasker Howard into the most extensive musical Americana collection anywhere. The Music Division also collected popular as well as classical music "long before," a former chief wrote, "the pop field became accepted, and even fashionable, in such halls of ivy as Yale and Princeton."

The other performing arts research collections – all later combined to form The New York Public Library for the Performing Arts at Lincoln Center – emerged in the 1930s out of various gifts and the curators' efforts to document the theater and dance. The resulting accumulations of theater and dance literature, archives, memorabilia, and multimedia documentation were among the first of their kind in the United States and unmatched anywhere.

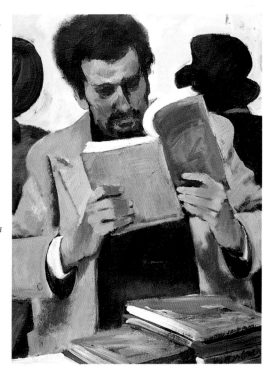

Serge Hollerbach,
"Reader in the
Slavic and
Baltic Division,
ca. 1920,"
1996. After
the Bolshevik
Revolution,
émigré scholars,
journalists,
and other
intellectuals
met at the
Slavonic Division
(as it was then
called) and
used its resources
for their writing
and research.

THE RESEARCH libraries, with their internationalist bent and broad subject sweep, had countless items in an estimated 1,400 languages and expressing many cultures; most of these were distributed among the subject divisions and general collections. There were also several renowned special units devoted to particular cultures or to materials in non-Western languages that required special expertise to administer. From the Astor Library came the Oriental Division, an exceptional group of materials in Asian and North African languages and literatures that in the twentieth century became a leading resource in its field; it includes strong holdings in linguistics, Egyptology, and Arabic literature as well as classic and modern works in other Asian languages, especially Indic. Two other separate units, unusual at the time, derived from petitions in the 1890s from the city's populous and intellectually vigorous (and largely overlapping) immigrant groups – Jews and Russians. These were the Jewish Division, a groundbreaking library devoted to a people and its languages and literature (including vernaculars such as Yiddish and Ladino), and the Slavonic Division (later called the Slavic and Baltic Division), which collected publications in Balto-Slavic languages.

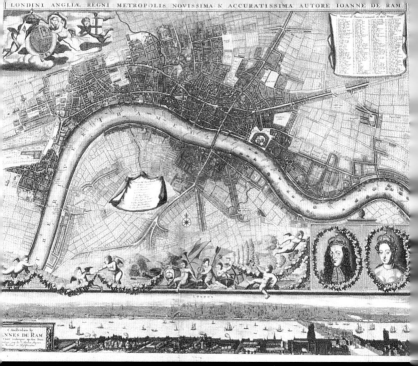

NDINI ANGLIAE. . . . AMSTERDAM, 1690.

The Map Division

In 1997, the Map Division acquired, from the estate of Lawrence H. Slaughter, a rare collection of maps, atlases, and books focusing on English mapping, especially of English Colonial North America, but including early Dutch and French maps as well. The collection complement the Map Division's holdings of some half a million books, maps, and atlases from the

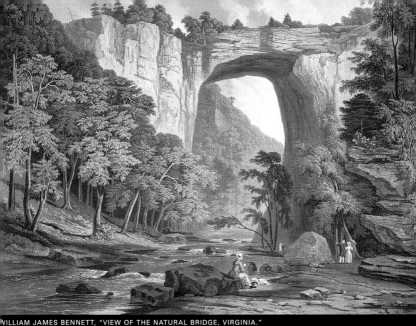

WILLIAM JAMES BENNETT, "VIEW OF THE NATURAL BRIDGE, VIRGINIA."
HAND-COLORED AQUATINT AFTER J. WARD, CA. 1835. I. N. PHELPS STOKES COLLECTION.

The Print Collection

Samuel P. Avery, a print connoisseur and former art dealer, gave the Library his personal collection of original etchings, woodcuts, and lithographs in 1900, to establish the first public print room in New York City and, apart from that in the Library of Congress, the first in an American public library. Today, the Library's Print Collection forms part of the Miriam and Ira D. Wallach Division of Art, Prints and Photographs, one of the greatest fine arts research collections in the world.

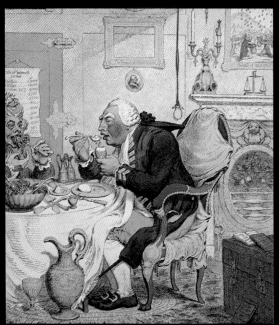

JAMES GILLRAY, "TEMPERANCE ENJOYING A FRUGAL MEAL."
HAND-COLORED ENGRAVING, 1792. BEQUEST OF SAMUEL J. TILDEN.

ALEXANDER AND ARCHIBALD ROBERTSON, "NEW YORK." HAND-COLORED ENGRAVING OF A VIEW FROM THE
SOUTH, CA. 1793. ENO COLLECTION.

Arturo Alfonso Schomburg, ca. 1905, whose collection formed the basis of the Schomburg Center for Research in Black Culture.

The Jewish Division was launched with several opportune purchases and gifts and was in part financially supported by local Jewish citizens, most notably financier Jacob Schiff. Jewish dreamers and intellectuals gathered to talk and read there, and the curators were personages in the New York Jewish community. The compilers of the monumental *Jewish Encyclopedia* in effect established their headquarters in the division, which also gave refuge during World War I to Eliezer Ben-Yehuda, the great Hebraist. The Slavonic Division was built by Avrahm Yarmolinsky over nearly forty years into a major resource for Slavic studies in the United States and one from which virtually every American writer in the field benefited. Russian émigrés in various political camps frequented the division, among them the future Soviet leader Nikolai Bukharin, who dragged Leon Trotsky, on his first

day in the city in 1917, to see The New York Public Library. In later years, succeeding groups of exiles and refugees would meet in these special libraries and use their resources in their writing and research.

In the 1920s, changing demographic and cultural trends produced another significant ethnic library at The New York Public Library – the present Schomburg Center for Research in Black Culture, originally part of the branch libraries. African American literature and documentation had been the province of the historically black colleges and not a serious concern of most other American libraries, one exception being The New York Public Library, which collected substantially in this field for the general research collections. Although the Library in principle was open to everyone without discrimination, there had not been numerous black readers. That situation changed after World War I, when the great South-to-North migrations in the United States transformed Harlem into the largest black community in the country. By virtue of numbers but also because of its lively intellectual and cultural life and the rise of new black nationalism and anti-discrimination movements, Harlem became "the black capital of the world."

Curator Dr. Lawrence Reddick and readers in the Schomburg Collection in its old building on 135th Street, 1940.

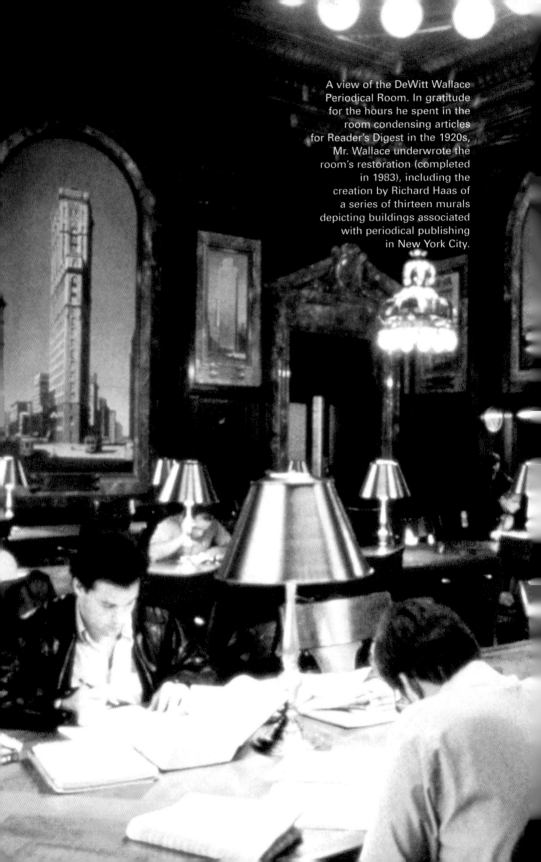

A view of the DeWitt Wallace Periodical Room. In gratitude for the hours he spent in the room condensing articles for Reader's Digest in the 1920s, Mr. Wallace underwrote the room's restoration (completed in 1983), including the creation by Richard Haas of a series of thirteen murals depicting buildings associated with periodical publishing in New York City.

Leading the Library's effort to serve this new clientele was the 135th Street Branch Librarian, Ernestine Rose, a white woman with an uncommon understanding of the aspirations and struggles of the black community; she worked with members of that community and hired the first black librarians in the Library system. Through art exhibitions, poetry readings, lectures, dramatic presentations, and concerts, the black intellectuals and artists whose consciously racial creativity and activism constituted the Negro or Harlem Renaissance of the 1920s found a home at the 135th Street library (later named for Renaissance poet Countee Cullen).

Rose also started in 1925 a reference library, the Division of Negro Literature, History and Prints, which a year later acquired a foremost collection of works by and about persons of African descent. This was the lifetime accumulation of Arturo Alfonso Schomburg, a native Puerto Rican of African descent who had long been active in African American historical circles. Schomburg's interests predated the Harlem Renaissance, but his knowledge and his collection were considerable components of that movement.

THE SYSTEMATIC, constant accumulation of research materials produced collections whose strength lay, a 1936 Library publication declared, "not only [in] the major works but also the minor things which, like the cells of a coral island, pile one on another to rise above the sea." By the time Lydenberg retired in 1941, The New York Public Library was among the mega-libraries of the world, its holdings of nearly three million books and pamphlets stellar in many fields, unique in certain fields, and noteworthy in others. Its status was achieved without the (free) copyright deposits received at the Library of Congress or reliance on faculty members as in the universities. Surveys, testimonials, and acknowledgments in books attested to the distinctiveness of the collections and their usefulness.

Levels of use were stunning. The trustees and librarians loved to boast about surpassing the Library of Congress and the British Museum in numbers of readers (and also about the quick delivery of items to readers). In 1930, for example, more than two million readers from all over the metropolitan area and beyond consulted nearly five million items in the research libraries. The librarians at the information desks were constantly busy helping people, and numerous queries were answered by mail.

Many young people who would become prominent or prosperous got a good deal of their education on 42nd Street or earned

The Dorot Jewish Division

The Dorot Jewish Division is one of the great collections of Judaica in the world, offering commentary on all aspects of Jewish life and history as well as Hebrew and Yiddish-language texts on general subjects. Its collections now number well over a quarter of a million items. Among its holdings are a splendid number of *ketubbot*, or marriage contracts, from eighteenth-century Italy; the example below shows the lavish devotion paid by Jews of the Italian Baroque to the beautification of the marriage celebration.

VLADIMIR VLADIMIROVICH MAIAKOVSKII, *MAIAKOVSKII DLIA GOLOSA* [*MAYAKOVSKII FOR DECLAMATION*]. BERLIN: LUTZE & VOGT, 1923.

AN ENGRAVED VIEW OF THE SANAKSARSKII MONASTERY OF THE VIRGIN, IN TEMNIKOV, SOUTHEAST OF MOSCOW. FROM: *ISTORICH-ESKOE OPISANIE SENOKSARSKAGO* [SIC] *MONASTYRIA*. MOSCOW, 1802. FROM THE CATHERINE PALACE LIBRARY AT TSARSKOE SELO, OUTSIDE OF ST. PETERSBURG.

The Slavic and Baltic Division

Among the more important collections of its kind in the Western world, the Slavic and Baltic Division collects in a dozen vernacular languages of Eastern and South Central Europe and the Baltic. Shown here are materials representative of the thousands of illustrated books and items of special provenance that constitute a significant feature of the Slavica holdings. The nineteenth-century engraved view (at left) of a Russian monastery is from a book once in the palace collections of the Romanov dynasty; the pages above are from a book by the Russian poet Vladimir Maiakovskii, illustrated by El Lisitskii, part of the Library's extensive holdings of avant-garde books, posters, popular prints, and dust jackets.

their livelihood from its information resources. In the current periodicals room, DeWitt Wallace labored for long hours in the early 1920s, hunting for material and condensing it for the innovative magazine, *Reader's Digest*, that he and his wife, Lila Acheson Wallace, were struggling to sell. Years later, Wallace, a multimillionaire as a consequence of the immense popularity of *Reader's Digest*, underwrote the renovation and restoration of the room, dedicated in 1983 as the DeWitt Wallace Periodical Room of The New York Public Library. The young Zionist David Ben Gurion researched his first book, *Eretz Israel – Land of Our Future*, in the Library in 1917. Norbert Pearlroth sat in the main reading room for fifty years searching for arcane information for the "Ripley's 'Believe It or Not!'" newspaper column. Among the many young people who used the Library as their high school and college were Martin Radtke, a Lithuanian immigrant whose years of study in the Economics Division taught him enough about the stock market to make the fortune that he left, in appreciation, to the Library. And Edwin Land, inventor of the Polaroid camera, and Chester Carlson, inventor of xerography, both depended on the Library in their early explorations into photographic processes.

THE VERY success of the Library created strains on its resources. Space in the central building for collections (and technical operations) began to run out, so that a structure planned for twenty-five years' growth was almost full in ten years. This is an inherent problem in any large research library, which by definition discards very little and must grow to remain viable. At The New York Public Library, periodic efforts to deal with space issues began in the 1930s with the purchase of a storage annex and the pioneering use of microfilm to store as well as preserve newspapers.

The number of readers as well as books also produced problems. An influx of readers, particularly students, jammed the main reading room and wore out certain books, to such an extent that "standing room only" signs went up. Finally, in 1930, the Library restricted use of the research libraries by high school and college students to those who could not find what they needed in their school libraries. This policy, which eased reading room space but created public relations headaches, continued until 1955 (although some determined college students, this author among them, had managed to skirt the rules and do their research at 42nd Street notwithstanding).

It was becoming apparent at the Library that something more was needed than the central research libraries and the circulating

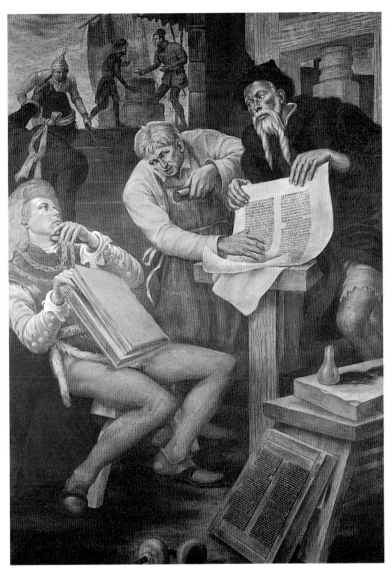

The murals by Edward Laning illustrating "The History of the Recorded Book" in the central building's third-floor rotunda were created in 1938–40 under the auspices of the WPA, a federal government work-relief program. Each of the four panels depicts a key stage in the technology of the recorded word: Moses with the stone tablets engraved with the Ten Commandments, a medieval monk copying an ancient manuscript, Gutenberg's invention of printing with movable type (shown here), and Mergenthaler's invention, in the United States, of the linotype machine.

branches that had originally seemed sufficient for the city. Librarians began pointing out that populous and information-hungry New York could use a substantial central college-level circulating collection, such as other American cities had, to accommodate a burgeoning student population and a wide public. The extent and complexity of The New York Public Library's research collections, daunting even to sophisticated users, could not best serve people who needed a much smaller range of materials.

The Library also felt financial pressures. The "Roaring Twenties" were a time of runaway inflation, which drastically affected Library salaries and book and binding budgets. Fortunately, considerable gifts from trustees and friends helped to keep things going and enabled the research libraries to more or less maintain collecting levels then and during the Great Depression of the 1930s. The Library also benefited during the 30s from the presence of hundreds of workers paid by the federal Works Progress Administration (WPA) programs, which placed unemployed people in jobs related to their skills or previous employment. But as the economic distress eased and the pre-World War II defense effort intensified, the work programs wound down, and by 1942 the relief workers were gone – and very much missed, especially as regular staff members left for war service.

THE WAR – a "good war," an all-out war that demanded, and got, tremendous public support – deeply affected the Library. Key staff members were drafted into the armed services or called upon for special government work. People asked for information

about war zones and war industries, and refugees tried to find information about their homelands and relatives. The Library's reading rooms served as an intellectual haven for refugee scholars. One of these scholars, not yet famous, was the French anthropologist Claude Lévi-Strauss, who lived in one room in Greenwich Village, met American ethnologists, taught at the New School, and spent long hours at The New York Public Library. He recalled his years in the United States as "completely decisive, the most fruitful period of my life. . . . Everything I know I learned in the United States."

Most significantly, the Library's collections furnished key information for the actual conduct of the war. Its books in "esoteric" languages and on non-European cultures and geography took on urgent importance in a war whose global scope revealed, even more than during World War I, deficiencies in American knowledge of the world. New York City was a center of intelligence gathering, and the Library supplied information, a good deal of it geographical and topographical as well as linguistic, to American and Allied government agencies. The Map Division in particular had special arrangements with the Army Map Service and the War Department's Office of Military Intelligence. "The ability to give this help," according to a 1942 report, came from the Library's "established policy to acquire . . . every kind of material which may have reference value in the several fields of knowledge and information the Library attempts to cover. Large collections which most readers might have characterized as useless clutter, proved to be exactly the things needed for detailed military planning."

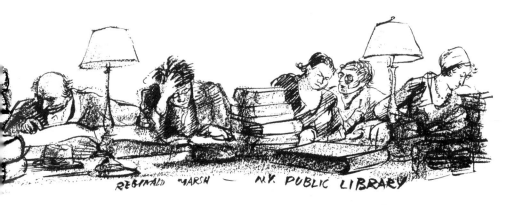

Reginald Marsh, "N.Y. Public Library," published in The New Yorker, *September 21, 1929.*

In this spirit, the librarians tried to gather documentation about the war and its effects. They acquired all sorts of ephemera (some received from Library employees serving in war zones), including underground publications from Nazi-occupied countries, documents of pacifist and "subversive" (pro-fascist) organizations, German and Japanese propaganda, and Allied military and intelligence documents.

The collections themselves faced war danger. After Pearl Harbor, New York City felt the threat of air raids and U-boat attacks and sabotage in public buildings. There were night blackouts and air raid drills. The Library stored its great treasures – the Spencer Collection, some 10,000 early printed books, 10 percent of the manuscript collections, and other special materials – in upstate sites or safe deposit vaults, and several special reading rooms closed for the duration of the war.

AMONG THESE precious items was a wonderful accumulation of books and manuscripts in English and American literature that had just come to the Library – the Henry W. and Albert A. Berg Collection. Its nature and origin epitomize the spirit of both New York City and The New York Public Library. The Berg brothers, prominent New York physicians and philanthropists, were the talented sons of poor Jewish immigrants on the Lower

William Makepeace Thackeray's oil and pencil self-portrait (top) and portraits of friends and colleagues executed on ivory, a treasure of the Berg Collection.

East Side. They went to the city's free college, City College, then to medical school at Columbia University, and on to distinguished careers, Henry as an infectious disease specialist, Albert as a pioneering surgeon. The bachelor brothers shared a home and a passion for books and reading that led to the accumulation of their "dear friends" – some three thousand choice books and manuscripts in American and English literature, with special focus on Dickens and Thackeray and other nineteenth-century writers. They also invested astutely in Manhattan real estate, which earned them the fortune to build their collection and to donate large sums to various institutions. One of the biggest beneficiaries was The New York Public Library.

In 1940, in memory of his brother, who had died in 1938, Albert Berg gave the Library their entire collection plus $250,000 for its upkeep in a separate room outfitted for the purpose. Soon afterwards Dr. Berg strengthened the collection, especially in twentieth-century authors, through the purchase and donation of two other famous private collections in American and English literature. The first was the W.T.H. Howe Collection of 16,000 books and manuscripts; then Dr. Berg joined Owen D. Young, chairman of the board of General Electric Company, in giving Young's more than 15,000 items to the Library. Altogether, these three founding gifts constituted what was called at the time "the largest and most important single collection ever presented to the Library"; it is still among America's most celebrated collections of first editions, rare books, autograph letters, and manuscripts. The Berg Collection expanded to occupy three rooms, with space for the many outstanding, urbane exhibitions mounted through the years. Dr. Berg also left the Library a further endowment to provide for the growth and care of the collection, which was nurtured by the first curator, John Gordan, and then by his protégé, Lola Szladits. Both were legendary figures in the Library who continued to enrich the collection, most notably with the works of contemporary writers.

At the formal opening of the Berg Collection in 1940, Mayor Fiorello LaGuardia, alluding to Nazi-overrun Europe, said, "It is so refreshing to be able to meet here, to accept this gift for the City, and to know that we still build libraries in this country. . . . We don't burn books or ban scientists, authors, writers, thinkers – what a contrast! – and that we still enjoy and appreciate the beautiful things of life."

"The Sovereign Hope
of
Learning"

Neighborhood Library Service

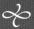

A young boy reading Robinson Crusoe *at the Fordham Branch Library (now the Fordham Library Center) in the Bronx, January 1924, in a photograph attributed to Lewis Hine.*

T HE LOCAL branches of The New York Public Library served "everybody" but did not try to acquire "every- thing." Essentially popular lending libraries of limited size (compared to the research libraries' huge holdings), they focused on the people in their communities. They exemplified what Arthur Bostwick, in his standard treatise on public library practice, a book based very much on The New York Public Library in the early twentieth century, termed the "modern

Poster listing the Library's free roof reading rooms on the Lower East Side, in the early part of the century. Said to be the first such reading rooms in the United States, they were constructed as a "refuge from sweltering streets and houses." The photograph is by Lewis Hine.

library idea." This was the concept that the public library should be "an active, not merely a passive, force" that would extend its reach "to the entire community, not merely to those who voluntarily entered its doors." It should "in all cases bring book and reader together." This process involved offering not only reading matter for adults but also children's rooms and story-telling, information service, advice on reading, services to special groups like visually handicapped persons, and traveling collections in homes, institutions, and work places. The modern library also cooperated with schools and other local organizations and sponsored reading clubs, lectures, concerts, and exhibitions.

We should remember that movies and radio were just begin-ning to challenge books, reading, live performances, and personal contact as major vehicles for human communication, and even by 1940 many people had no telephone. Few persons had gone beyond the eighth grade in school, and compulsory high school attendance was new. School libraries were either nonexistent or very bad. Working people could not afford to buy many books and had limited opportunities for further education. Places for people to gather freely were not numerous, and young people could not easily get together in crowded flats or find a quiet

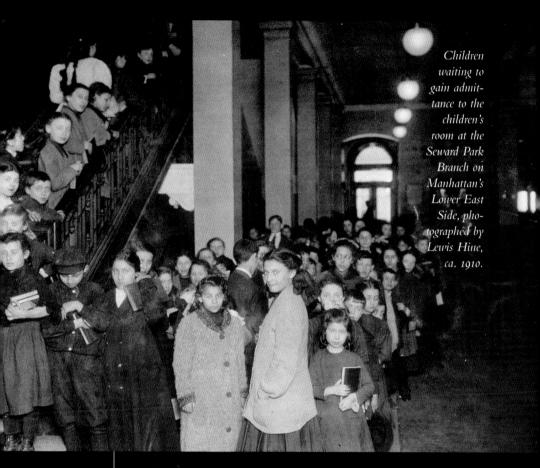

Children waiting to gain admittance to the children's room at the Seward Park Branch on Manhattan's Lower East Side, photographed by Lewis Hine, ca. 1910.

The Seward Park Library was a mecca. It was always busy and at any time of day or night you could see people on the streets, arms laden with books. The tenements were hovels, and the library was a wonderful place to go. The librarians were strict, but friendly. They insisted on order and quiet, and really looked to see if your hands were clean – not only to protect the books, but to prevent the spread of disease.

Women didn't use the library much. Many weren't literate. Those who could read were too busy with the laundry, cooking, shopping, and baby after baby. The men went at night after work. They all wanted to read the newspapers. The library was a wonderful place – one of the most important parts of my life.

FROM THE RECOLLECTIONS OF A RETIRED NEW YORK CITY SCHOOLTEACHER AND PRINCIPAL, *given to the author, early 1970s.*

spot at home to read or study. And New York, whose population doubled from 1900 to 1930, reaching a record seven million, teemed with immigrants struggling to adjust to a new world. For the masses of men, women, and children crowding the branches, The New York Public Library represented, as Timothy Healy, a later president of the Library, would put it in another time of social change, "the sovereign hope of learning."

The New York Public Library neighborhood librarians, led most devotedly from 1919 to 1941 by chief Franklin F. Hopper, wanted to help people fulfill that hope. The librarians did this with optimism, pragmatism, vitality, some paternalism, and a minimum of moralizing. Partly because of the branch system's origin as a conglomeration of local libraries and partly because of the Library's community-centered philosophy of service, Hopper gave his administrators and branch librarians scope to adapt collections and services to their communities. Indeed, librarians' effectiveness was judged by how well they knew their communities.

The librarians in the branch system resembled social workers, who, as part of the Progressive reform movement of the time, campaigned for improved housing, schools, health, and working conditions for the masses and worked in the neighborhoods to help people, especially immigrants, cope with their lives. The New York Public Library's librarians believed they too had a mission to bring knowledge and culture to the masses, but with an uncommon concern for what their users wanted and needed for themselves. The nature of public libraries lent itself to this outlook. They were open to all, on a voluntary, informal, and individual basis, and in pleasant and inviting surroundings. The librarians were also humanistic in a cultural sense. Although pleased to report increases in circulation of nonfiction books as evidence of their "serious," educational role, they defended offering materials that gave pleasure and distraction. The Library did not exist "only to own and circulate books of fact." Culture encompassed both imagination and fact; people needed both, and a novel could be as truthful as a biography or a work of philosophy, science, or history.

THE NEW YORK Public Library's approach applied most significantly to the famous work with immigrants and their children. New York had always been cosmopolitan and polyglot. Indeed, one of the city's unique features, and for many its charm, has been the variety and number of its "foreign" colonies. At the turn of the nineteenth century, New York, chief port of entry

Imparate l'Inglese !

Lezioni gratuite per adulti di ambo
i sessi, dalle 7.30 alle 9.30 p. m.
Di Inglese, Storia, e di elementi di
Economia Politica.

Si offrono informazioni sull'acquisto
della Cittadinanza Americana

Libri in Italiano ed in Inglese

Tompkins Square Branch
331 East 10 Strade
della Biblioteca Pubblica di Nuova York

רערנט ענגריש!

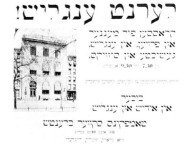

פֿראסטין פֿיר מיננער
אין פֿרייע, אין ענגליש,
געשיכטע אין סייענס.
א ט 9.30 — 7.30 ב

ביבליטעק
אין אידיש אין ענגריש
מאנפֿקינס סקווער ברענטש
331 עסט 10 סטרים
א־ן ---- ---- --- --- ---

Ucz się Angielskiego !

Darmo klasy dla Mężczyzn i
Kobiet. Język Angielski, Historja,
Obywatelstwo. 7.30 do 9.30
wieczór

Pomoc jak otrzymać papiery
obywatelskie

Biblioteka wypożycza polskie i
angielskie książki

Tompkins Square Branch
331 East 10a Ulica.
Oddział New Yorkskiej Publicznej Biblioteki

Tanuljon Angolul

Ingyenes oktatatás nők és férfiak
számára. Angol nyelv,Történelem,
Közigazgatás. Estenként 7.30—
9.30 ig.

Segédkezünk a polgárlevél
megszerzésében

Magyar es angol könyvek

Tompkins Square Fiók
331 East 10. ik utca
New Yorki Nyilvános Könyvtár

*"Learn English!" handbills from the Tompkins Square Branch, in Italian, Hebrew,
Polish, and Hungarian, October 1920.*

for immigrants into the United States, was crowded with "new"
immigrants – mostly poor Slavs, Italians, and Jews, with their
exotic foods, strange languages, and peculiar customs and reli-
gions. In 1910, the proportion of foreign-born residents reached
a high of nearly 41 percent (two-thirds from southern and eastern
Europe), nearly three times the national percentage. By 1930,
even after the restrictive immigration law of 1924 had taken
effect, the proportion remained high, 34 percent; the number
of children of immigrants was higher.

Although they did want to see the immigrants learn
American ways, the New York librarians adopted a benevolent
stance on that major question of the day, "Americanization."
They followed neither the standard pattern of urging total con-
formity to a supposedly superior white, Protestant, Anglo-Saxon
model suitable for a republic nor the "melting pot" viewpoint,
the jumbling together of all cultures to produce one homogen-
ized, American product. The New York librarians differed from
colleagues in other cities (and also from teachers and early social
workers in New York) in taking a position resembling cultural

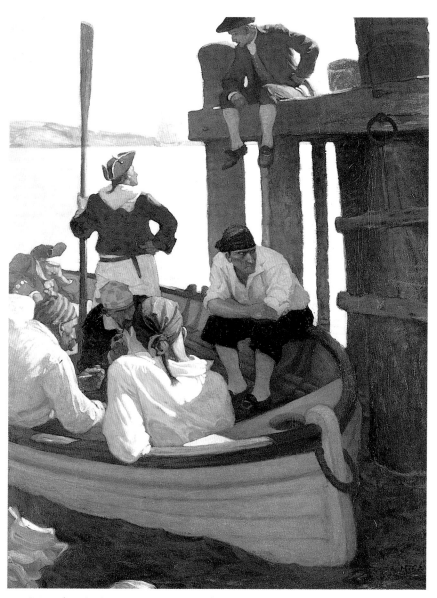

N. C. Wyeth, "At Queen's Ferry," a scene from Robert Louis Stevenson's Kidnapped, *one of the oil paintings executed by Wyeth to illustrate the 1913 edition of the novel published by Charles Scribner's Sons in New York. The original painting hangs in the Central Children's Room, Donnell Library Center.*

pluralism – the idea, emerging in 1915, that in a democracy the cultures of its constituent groups enrich the society and should be preserved. Esther Johnston, a later chief of the branch libraries, commented on her work among immigrants: "The melting pot or Americanization idea, it always had something that was a little chauvinistic about it, and that was one reason we wanted books in the foreign languages; we wanted exhibits so that children could see the culture from which they had sprung and [we] didn't think that forced interest in American life was very wholesome. . . . Our [aim was to provide] good reading matter and [we hoped] that the ones who read it would a little sooner find themselves understanding the country."

For immigrant adults, the branches at first focused on providing English-language books; they also served as sites for English-language classes sponsored by various groups. Gradually they began to stock materials in other languages, a practice that prompted criticism in the press and from within the library profession. It was cruel, Library spokesmen said in response, to deny reading matter to people too old or too exhausted by their labor to learn English; besides, the right books in any language would introduce them to American life and ideals. What also happened was that the librarians began not only to sympathize with people trying to make their way in a new culture but also to appreciate non-Anglo personalities, languages, food, and customs and finally to defend them from nativistic prejudices and fears. It was "of the greatest importance," Esther Johnston wrote in 1921 when she was chief of the heavily used Seward Park Branch on the Lower East Side, "that the library should in every way show respect for the opinions, customs and religions of [the older immigrants] whom American life treats cruelly."

Librarians developed substantial foreign-language collections of books, newspapers, and magazines for adults in the branches; these and ethnic cultural programs became a source of pride for the Library. By 1930, the branches contained nearly 122,000 books in twelve foreign languages plus miscellaneous others, some 13 percent of the entire book stock. Other acknowledgments of the realities of serving ethnic groups were book lists, posters, and leaflets printed in several languages, as well as the appointment of librarians who knew foreign languages and literature and could deal with non-English-speaking readers. The entire staff, however, was expected to acquire an "intimate acquaintance" with "the history, tradition, and literature of each nationality that the library expects to serve." The extension of

MIREILLE LEVERT (1995).

EDWARD GOREY (1972).

WALTER CRANE (FIRST PUBLISHED 1874).

CHARLES ROBINSON (1913).

The Central Children's Room Collections, Donnell Library Center

The Central Children's Room (originally located in the central building on Fifth Avenue, but now in the Donnell Library Center on West 53rd Street) is a treasure-trove – numbering over 100,000 volumes – of rare and early children's books, original illustration art, and books on the history and criticism of children's literature. In addition to legions of children, its most frequent visitors include teachers, authors, and illustrators. These illustrations of the classic fairy tale "Red Riding Hood" are drawn from a selection of editions in the collection.

Anne Carroll Moore, The New York Public Library's first head of Children's Services, in her office in 1906.

evening hours in several branches was really a special service for the young adult immigrant readers who spent long, hard days in shops and factories.

CHILDREN RECEIVED special attention in all the branches of The New York Public Library under the dynamic leadership of Anne Carroll Moore, a doyenne of children's librarianship and literature. Moore insisted on respect for children and on quality books for them. Her work over thirty-five years at the Library not only made children's services there celebrated in the field but helped powerfully to raise children's librarianship to respected status and to stimulate quality publishing of juvenile books. She built the Central Children's Room on Fifth Avenue into a fine collection of domestic and foreign books, new and old, commonplace and rare, that became a children's literature center as well as a circulating library and reading room for children.

Her librarians helped children with school work, but she believed that the greatest contribution of the public library children's room was "its recreation value – to inspire a love of reading for reading's own sake for the pure joy and refreshment it gives throughout life and in so doing to create associations with a room quite different from a school room, a room which grown men and women will remember always and love to look back upon." And they did. Travel writer Kate Simon, who grew

up in the 1920s Bronx, expressed it exactly: "The library, which made me my own absolutely special and private person with a card that belonged to no one but me, offered hundreds of books, all mine and no tests on them, a brighter, more generous school than P.S. 59." And a noted English professor recalled the Central Children's Room: "What I loved about that room was the window seats. You could sit there all day and read and nobody on your back." A retired Hebrew schoolteacher felt she'd spent her best years in the Rivington Street Library: "We had no movies or radio, so reading meant everything. There was a tremendous desire to learn. I went to the library every free moment I had."

Moore accomplished her goals through training a cadre of enthusiastic children's librarians, careful book selection, a model storytelling program, and the organization of reading clubs and interesting programs and exhibitions. She encouraged the staff

Tigger, Kanga, Winnie-the-Pooh, Eeyore, and Piglet — the original toys that inspired the A. A. Milne classics. Given to the author's son, Christopher Robin Milne, between 1920 and 1922, they were donated to the Library in 1987, where they have found a home in the Central Children's Room in the Donnell Library Center ever since. In 1998, they were at the center of an international incident, when a British Member of Parliament demanded, unsuccessfully, their return to English soil.

Children in the Library

The art of storytelling has flourished at the Library since 1906, when the branches began offering special services to children. Among the legendary storyteller-librarians in the Library's history was Augusta Baker, Coordinator of Children's Services from 1961 to 1974, whose personal flair for bringing folk tales alive for young listeners is memorably recorded in the photograph opposite.

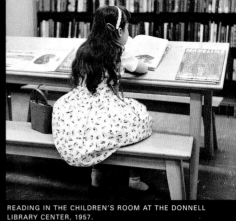

READING IN THE CHILDREN'S ROOM AT THE DONNELL LIBRARY CENTER, 1957.

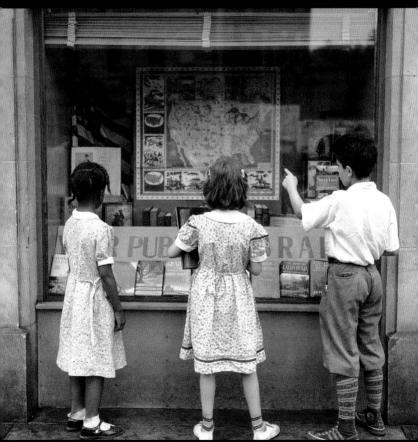

LOOKING AT A WINDOW DISPLAY AT THE GEORGE BRUCE BRANCH LIBRARY ON 125TH STREET, JUNE 1937.

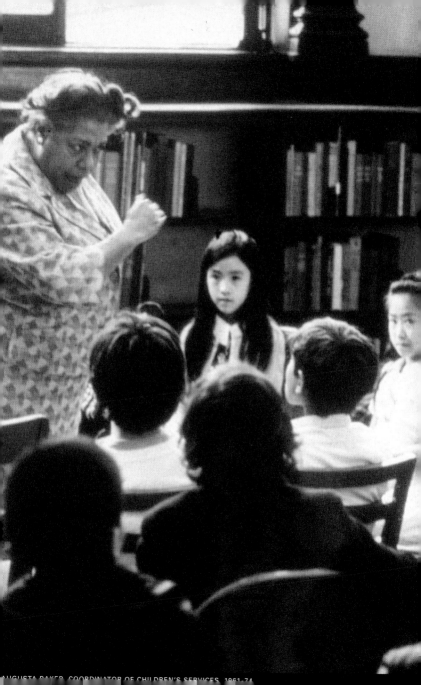

ABOVE *The card catalog at the Library for the Blind, the first of the branch system's several special circulating collections, 1962.*

LEFT *A poster by Charles M. Schulz for the Library for the Blind.*

to celebrate holidays, characters in children's books, authors' birthdays, or local ethnic cultures. These "bookish affairs and fetes," her biographer and successor at the Library, Frances Clarke Sayers, wrote, were "created by an imaginative staff to bring drama into the quiet business of reading and to heighten the common day for thousands of children who trudged up and down the steep stairways of branch libraries to second floors, day after day, in search of pleasure and diversion."

Many if not most of these thousands were immigrant children or the children of immigrants, whose eager use of The New York Public Library was documented in photographs by Lewis Hine.

Drably but neatly dressed, they stand in long lines waiting to go into the library, read quietly on little chairs, listen intently to stories, gather around a table to discuss books. The librarians wanted the children to read in English, but in contrast to the Anglo-conformist content and attitudes transmitted in the public schools, they made special efforts to connect children to their parents' culture. Moore, liberal in her thinking and genuinely fond of cultural diversity, was sensitive to the well-known generation gap between parents steeped in Old World traditions and their "Americanizing" children. Children's programs featured ethnic festivals, exhibits, and puppet shows, folklore from various traditions, and the display of foreign-language children's books. Librarians organized mother's clubs and in several neighborhoods visited parents to get signatures on children's registration blanks and introduce them to the library.

The best way, Moore believed, to give children "a feeling of pride in the beautiful things of the country [their] parents have left" was through the then novel library practice of storytelling, some of it bilingual. Story hours, which Moore ordained for every branch, became a special and influential feature of the Library's work with children. Several thousand regular sessions were reported each year, along with many others held informally in playgrounds, schools, and settlement houses.

BESIDES THE neighborhood libraries, within the branch system there were also several special circulating collections geared not to a particular locale but to interested people from any part of the city. The first in time of origin was the Library for the Blind, derived from the former New York Free Circulating Library for the Blind, which had joined The New York Public Library in 1903. The branch stocked and produced braille materials, taught people to read them, and circulated them, postage free by federal law, to users in the metropolitan area. A center for library service to blind persons, a field that for a long time was not well developed in this country, the branch issued in 1930 the first braille catalog of American library holdings in braille, and the next year inaugurated the *Braille Book Review*. When the federal government began to operate a national network in 1931 to circulate books, free of charge, to blind adults, The New York Public Library was designated a distribution center; in 1934 it announced receipt of the first "talking books" plus a phonograph machine.

The renowned circulating Picture Collection, five million items strong by 1995, started in 1915 with some 18,000 pictures to meet the many requests from people in the graphic arts, publishing, theater, motion picture, advertising, and fashion industries who were constantly looking for useful or inspirational images. The collection's growth in response to modern visual culture was led by Romana Javitz, chief from 1929 to 1968 and a dominant force in picture librarianship. Attuned to artists' and designers' purposes, she shaped the collection into an eclectic resource. It included clippings from books and magazines and contemporary photographic prints, organized with an understanding of their cultural, historical, and formal content and contexts. That approach informed the multifaceted indexing system Javitz devised to access the pictures, as pictures, not books; in acknowledgment of the nonverbal character of visual documents and also to help non-English speakers, users could submit on call slips sketches of what they were looking for. In the process of collecting visual documents, Javitz encouraged the work of photographers, like Lewis Hine and Walker Evans, who later achieved fame for both the documentary and artistic quality of their work. Her greatest coup was the acquisition of the extraordinary Farm Security Administration series, administered by Roy Stryker, of classic photographs of America and Americans during the Great Depression (later transferred, for preservation purposes, to the Miriam and Ira D. Wallach Division of Art, Prints and Photographs in the research libraries).

The third special collection was established in 1920 as a complement, so to speak, to the Music Division in the research libraries. The scores and musicological holdings, and, later, phonograph records, of the Music Division could be consulted only on the premises. But musicians, composers, and music teachers and students also needed to use these materials outside the Library for study and performance, a need that became more pressing when music shops in the city stopped allowing sheet music to be taken home on approval. In 1920, the 58th Street Branch was designated as the music center of the branch libraries and quickly became a busy gathering place for the city's music community and a haven for aspiring musicians. (These music collections are now part of The New York Public Library for the Performing Arts, at Lincoln Center.) Composer Milton Babbitt recalled that he and his friends "took everything we ever learned out of that library," where they were also able to study "a little fiefdom of scores that were not allowed to circulate, that were not obtainable or

Art Spiegelman, "WORDS, Worth a Thousand," one of four pages illustrating the story of the Picture Collection. The piece was first published in The New Yorker, double issue February 20/27, 1995; this copy was inscribed for the Library by the artist at the top of this page.

available anywhere else" and had never been recorded. One could hear them only by looking at them, "and they were the most exotic, recondite things we could imagine. And by the way, that is the only way I have heard most of those scores, even to this day."

POPULATION AND residential shifts in the ever-changing city affected the branch libraries. Previously crowded downtown neighborhoods thinned out, and several branches closed as Manhattan residents moved north and to areas of the Bronx and Staten Island where library service was sparse or nonexistent. The Library did what it could to satisfy demands for branches, but it had limited resources. After World War I, the final two Carnegie branches went up in the Bronx, and in 1922 a bookmobile began service on still rural Staten Island. Sub-branches and stations, along with the traveling deposit libraries, also tried to reach people without a regular library, but all that was not nearly enough. By 1929, when the Carnegie fund ran out, the Library itself had no money for construction. The advent just then of the Great Depression inhibited substantial municipal spending on library buildings, though in the 1930s

There was no place to study at home, a cold water apartment with no steam heat; the stove was in the kitchen and it was always cold. So my study was the library on 10th Street, right opposite Tompkins Square Park between Avenues A and B. It was a fine, warm, clean place, and there were lovely librarians, with blond hair and blue eyes and elegant accents. The attraction was magnetic. And they put me on to some great books.

E.Y. "YIP" HARBURG
librettist, lyricist, and author, in "From the Lower East Side to 'Over the Rainbow,'" in Creators and Disturbers: Reminiscences by Jewish Intellectuals of New York, Drawn from Conversations with Bernard Rosenberg and Ernest Goldstein *(1982)*

Yip Harburg's lyrics and Jay Gorney's music for "Brother, Can You Spare a Dime?" (1932) made the song a Depression-era classic.

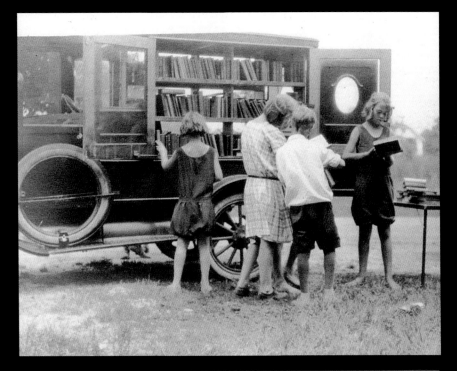

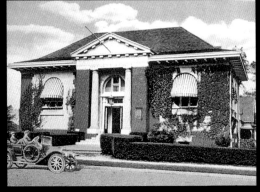

A photograph of the Extension Division book truck, near the beach at Eltingville, Staten Island, ca. early 1920s (above), and a postcard showing the Port Richmond Branch in Staten Island, 1905, designed by John Merven Carrère and Thomas Hastings, the architects of the famous central building.

the city did construct one new branch each in Staten Island and the northern Bronx.

Equally if not more problematic was a severe scarcity of money for the existing branch library system. This situation, which originated in the inflationary 1920s, became even more drastic during the Depression when, as in libraries everywhere, municipal funding was sharply reduced while use surged.

Following the nationwide trend, demand for library service in New York went up as the economy went down. Unemployed workers frequented the branches – to while away their time by reading, to research employment opportunities, and, quite important, to find information about qualifying for civil service jobs. Such users, a 1936 Library survey reported, found the Library "a godsend," "a haven of refuge in this city of a million noises, and during a period when unemployment has left every nerve on edge." The always numerous student users were augmented by young people who were going to school, day and evening,

During the Depression, the Library operated an Open-Air Reading Room (shown here in 1938) in Bryant Park behind the Fifth Avenue library, where people, many of them unemployed men, could sit and read books and magazines.

because they couldn't find work. In 1931, to offer an alternative to use of the research libraries and to attract students, the Bronx Reference Center opened in the Fordham Branch, and other branches reported higher levels of reference work with students.

Appropriations for the branches were cut to the point where hours and extension services had at times to be curtailed and employees "furloughed" (temporarily laid off). The 1933 municipal appropriation for the purchase of new books, periodicals, and binding went down 77 percent from the previous year. Heroically trying to serve everyone despite depleted collections, the Library lowered the number of books permitted per borrower – an unpopular policy – and librarians encouraged reading of older, classic works and formed circuit collections of certain books.

In the summer of 1935, the Library launched an Open-Air Reading Room in Bryant Park behind the Fifth Avenue library, staffing it with the unemployed themselves – WPA workers who had become indispensable in the branches at a time when budgets were so terribly thin. They did certain jobs for which regular employees never had the time. The Picture Collection used relief workers extensively to index, file, mend, mount, and clip pictures, and many others, including trained musicians, worked at the 58th Street Music Library, copying, repairing, and binding music scores and doing bibliographic jobs. WPA workers kept branches in good repair, and they built a small new Bronx branch and several branch extensions.

In 1932, the Library received help from another source to pursue an experiment in a new American public library venture, "adult education." For three years, the American Association for Adult Education sponsored library adult education programs in Harlem. Although the Library had always functioned as a self-education agency and furnished meeting spaces and materials to local educational groups, a more targeted approach surfaced at this time as part of the contemporary adult education movement in the United States and as the need for special services for immigrants declined with the decline in immigration. The central Readers' Adviser service, started in 1928 by Jennie Flexner, a nationwide leader in the field, was extended to the branches. This involved systematically guiding self-motivated readers and furnishing information about community educational organizations. The new "adult education" went further: librarians were to be pro-active in stimulating reading (commonly in English but not always), through group book discussions, public lectures and forums, musical and dramatic presentations, and the issuing of lists

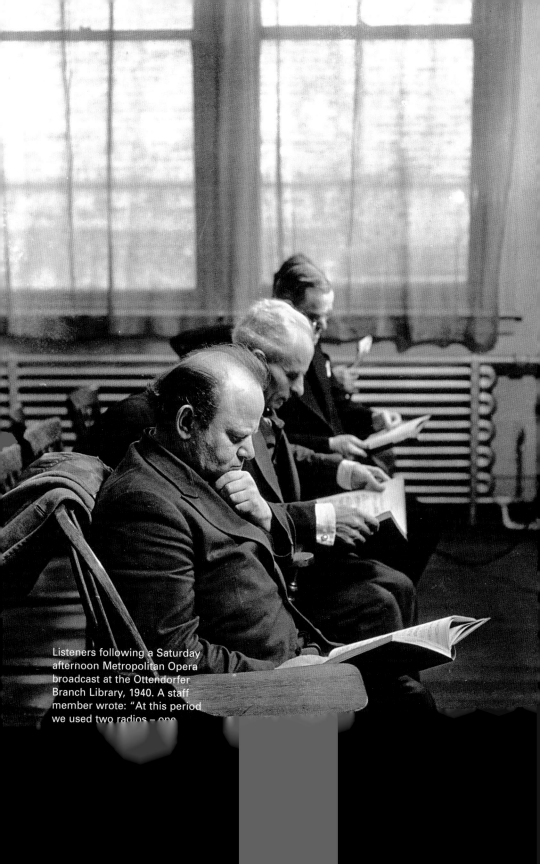

Listeners following a Saturday afternoon Metropolitan Opera broadcast at the Ottendorfer Branch Library, 1940. A staff member wrote: "At this period we used two radios – one

of recommended books. Much of this activity had already gone on in The New York Public Library's branches on a pragmatic basis, and all of it eventually evolved into what would later be called adult services – offerings that appealed to the public's interest in informal literary and cultural experiences rather than education per se.

By 1939 and 1940, the pervasive influence of the Depression tapered off as economic conditions improved and defense industries began to boom; after December 7, 1941, World War II dominated Library reports. The branches lost relief workers to war industries and employees to war service, conditions in society in general that also reduced use of libraries. Most of the branches of course were not as equipped as the research libraries to contribute to the actual operation of the war, but they did their part for morale on the home front, and the Picture Collection supplied images to intelligence and propaganda agencies. In part to compensate for the chronic lack of books but, more important, to contribute to the war effort, the branches became unusually active in civic affairs. Each branch served as a community center for war information and for civilian defense agencies, and librarians became involved in all sorts of war-related organizations; the 58th Street Branch ran a music canteen for servicemen, and a book canteen for them opened in the Fifth Avenue building.

The New York Public Library began seriously to plan ahead as the end of the war came in sight. Problems and prospects held in abeyance would now be tackled in earnest; these involved not only financial support but the long-term issues of space and the need for a more substantial central circulating library. The entire Library looked forward to a brighter future in an expansive postwar world.

Over the decades, as the neighborhood around it has changed, the Ottendorfer has always been well used: first by Germans; in the thirties and forties, by refugees from Hitler (Bertolt Brecht lectured at the library in the thirties, and Rudolf Serkin played a recital there around the same time); and now by Ukrainians, Chinese, Puerto Ricans, Ecuadorians, and Poles, among others.

ANTHONY HISS
"The Ottendorfer," The New Yorker, *October 1, 1979*

"An Empowering Mechanism"

Modernization and Growth

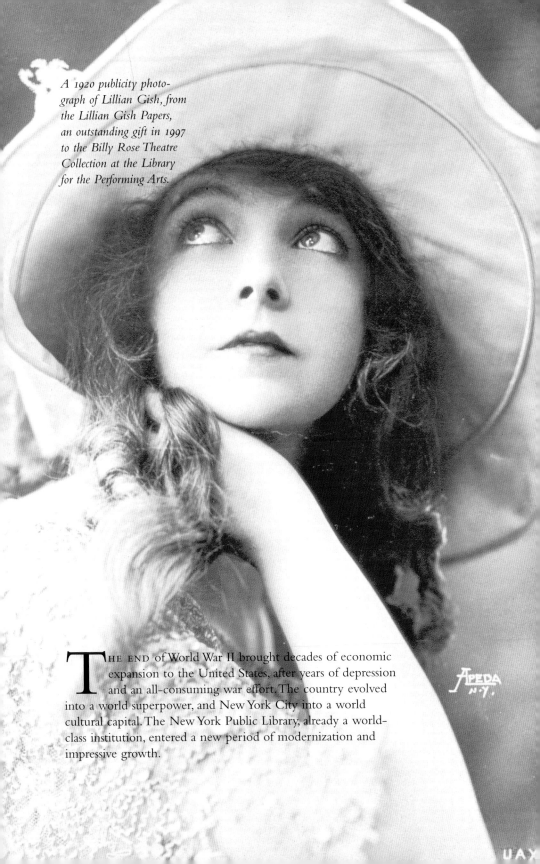

A 1920 publicity photo-
graph of Lillian Gish, from
the Lillian Gish Papers,
an outstanding gift in 1997
to the Billy Rose Theatre
Collection at the Library
for the Performing Arts.

APEDA
N.Y.

THE END of World War II brought decades of economic
expansion to the United States, after years of depression
and an all-consuming war effort. The country evolved
into a world superpower, and New York City into a world
cultural capital. The New York Public Library, already a world-
class institution, entered a new period of modernization and
impressive growth.

To launch the Library on its postwar course, the Board of Trustees broke with tradition in their choice of a new Director in 1946. They went outside the Library to appoint Ralph A. Beals, director of the University of Chicago Library and dean of the university's distinguished Graduate Library School. Brilliant, forceful, and committed to both the scholarly and popular dimensions of librarianship, he reorganized and revitalized the entire Library.

The branch system experienced something of a renaissance. Public libraries all over shared in the extraordinary postwar growth in the United States. But this time no Andrew Carnegie appeared: funding for libraries derived almost entirely from the public purse, both state and local. Only after World War II did most American state governments, prodded by activist librarians like Beals in New York, meaningfully subsidize and stimulate public library service in the interest of promoting popular education. The City of New York carried out its plans for postwar library service in the construction of new branches and the rehabilitation of others. By 1956, the now eighty branches, covering the three boroughs, had total collections of over two and a half million volumes and a circulation of some twelve million volumes a year.

The expansion continued into the next decade and included one of the city's most prominent restoration projects generated by the historical preservation movement of the 1960s. In Greenwich Village, neighborhood people wanted picturesque "Old Jeff," the nineteenth-century Jefferson Market Courthouse, shabby and vacant, its clock tower a neighborhood landmark, o be the site of a new large library branch. The Library agreed and commissioned Giorgio Cavaglieri, president of the Municipal Art Society and a leading preservation architect, to design the conversion. Within the exterior shell, an American version of "Ruskinian Gothic" architecture replete with turrets, towers, and gables, he introduced modern elements – fluorescent lighting, modern furniture, travertine flooring, elevators, and a catwalk above the main reading room – into the Victorian interior. "Old

> **The atmosphere in which literature and knowledge are dispensed is part of a cultural package. Today it is the fashion to offer a kind of statistical, book-counting culture in visually illiterate surroundings. At Old Jeff there is also the literature of architecture: cut stone faces and flowers, spiral stairs, soaring stained glass windows, the feeling, form and sensibility of another age. This, too, is the record of civilization.**
>
> ADA LOUISE HUXTABLE
> The New York Times, *November 28, 1967*

A stained glass window in the grand spiral staircase at the Jefferson Market Regional Branch Library.

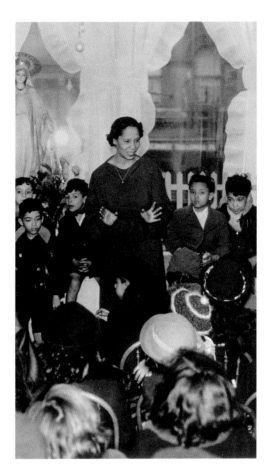

One of the Library's most accomplished bilingual storytellers was Pura Belpré, the first Hispanic assistant hired by the Library. Belpré became the first public librarian in the United States to record and preserve Puerto Rican folklore and was a pioneer in reaching out to New York's growing Puerto Rican population. She is shown here at the 115th Street Branch Library, ca. 1938–39.

Jeff" was imaginatively turned into the much-admired, much-used Jefferson Market Library, up to date yet retaining its original architectural identity.

In the 1960s, the federal government for the first time became a significant player on the American urban library scene, with the Library Services and Construction Act and President Lyndon B. Johnson's "Great Society" legislation. At The New York Public Library, such funds underwrote, among other things, outreach projects in North Manhattan and the South Bronx. The North Manhattan project targeted the predominantly African American community in Central Harlem and called upon the resources of the Countee Cullen Branch and the Schomburg Center to enrich materials on African American life in all the branches

in the district. The South Bronx project responded to the influx into the city of poor Puerto Rican migrants and other Spanish-speaking people. In nine South Bronx branches, neighborhood residents could find bilingual staffs and tens of thousands of Spanish books. A special focus was on children, and the librarians worked in cooperation with the new Head Start and other anti-poverty programs. In many ways these projects were a reprise of the ethnic outreach in the branches a generation and more earlier. The specifics and the contexts might be different, but not the basic approach. Pura Belpré, the prominent bilingual children's librarian and storyteller, writing in 1964 about the Spanish story hours held in the branches, expressed the spirit: "Through the power of a story and the beauty of its language, the child – for a while at least – escapes to a world of his own. He leaves our room richer than when he entered it."

SEVERAL IMPORTANT new library centers also went up during the postwar decades to meet needs for more extensive library service in Manhattan and in the process help to relieve space pressures caused by the constant growth of the research collections. The first of these centers, the Donnell Library, which opened in 1955, was also the first major public library building in Manhattan in years. Located on East 53rd Street off Fifth Avenue, opposite

A view of the Donnell Library Center, 1995.

A filmmaker browsing at the Donnell Media Center, ca. 1983-84. The Media Center holds one of the world's finest documentary film archives.

the Museum of Modern Art, it was a welcome addition to its busy midtown neighborhood. As a piece of architecture, however, it inspired controversy. Midtown Manhattan was being filled with new skyscrapers in the austere International Style of modern architecture that the Donnell expressed on a small scale. *The New Yorker* found its glass and stone facade "chillingly severe," and architecture critic and historian Lewis Mumford, in a broadside against the International Style, excoriated the facade. The interior, though, he deemed "unusually gracious" and in "excellent taste," with good proportions and a "hospitable," even "elegant" air. As a library it undoubtedly succeeded, with book circulation soon approaching a million items a year, much higher than anticipated.

The Donnell offered the public a wealth of services and collections. A multimedia unit stocked 16 mm. films and audiorecordings for circulation, at a time when such service was still experimental in the print-oriented American public libraries. Besides the general book collection for adults, there were a children's room and the largest teenagers' library in New York and, gathered from certain branches where non-English-speaking residents no longer lived en masse, a consolidated, much-used world languages collection.

*"Books for the Teen Age –
1977," a poster from the
Office of Young Adult
Services, promoting one
of the bibliographies
published by the Library.*

The New York Public Library

The second major project reflected the Library's close
connections with the city's flourishing performing arts scene.
The Library joined an innovative private-city-state-supported
enterprise, the Lincoln Center for the Performing Arts on the
Upper West Side of Manhattan. This grand cultural complex,
designed by leading architects, would bring together the New
York Philharmonic, the Metropolitan Opera, the Juilliard School,
the New York City Opera, and the New York City Ballet, along
with a new repertory theater company. The presence of the
Library & Museum of the Performing Arts (as it was first called),
offering, free of charge, facilities for research, study, circulation,
and exhibition in all the performing arts, helped the entire
Lincoln Center project win public acceptance.

All of The New York Public Library's performing arts collec-
tions, reference and circulating, moved in 1965 to Lincoln Center,
where the staff could cater to ever more users and could better
care for the some four million items related to almost any and
every type of performance, many of them in nonbook form –
audio and video recordings, manuscripts, sheet music, stage
designs, press clippings, programs, posters, photographs, and mem-
orabilia. Gifts of papers and mementos from prominent figures
in the performing arts or their foundations enriched the already
impressive research resources. The names of important collections

By 1964, the Foreign
Language Library (now the
World Languages Collection)
had grown to 40,000 books
in eighty languages. Shown
here is a sampling of editions
of Shakespeare, available
at the Donnell Library, in
(left to right, from top left)
Finnish, Modern Greek,
Japanese, Turkish, Yiddish,
Hungarian, Spanish, and
Estonian.

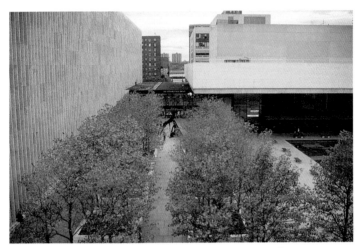

The entrance to The New York Public Library for the Performing Arts at Lincoln Center, shown in November 1986, is nestled between the Metropolitan Opera House (left) and the Vivian Beaumont Theater.

indicate just a few of these contributions: the Billy Rose Theatre Collection; the Rodgers & Hammerstein Archives of Recorded Sound (which enabled the Library's 90,000 audiorecordings to be brought out of storage and used by the public); the Jerome Robbins Archive of the Recorded Moving Image; the (Arturo) Toscanini Memorial Archives (microfilms of music manuscripts by great composers); and the Cia Fornaroli Collection (a 40,000-item collection of historical materials and memorabilia related to the dance, donated by Toscanini's son Walter).

The Robbins Archive, formally dedicated to the great modern choreographer in 1987 as a unit of the Dance Collection (renamed in 1999 the Jerome Robbins Dance Division), was begun in the mid-1960s. At that time, helped by Robbins, the Dance Collection, which curator Genevieve Oswald had built from practically nothing into the most extensive and most varied dance archive in the world, moved beyond collecting documents to creating them as well, by capturing, on film and then video-tape, live dance performances and by conducting oral history interviews with dance people. The Theatre Collection, too, through the unique Theatre on Film and Tape Archive, docu-mented performances by recording on videotape selected theater presentations from around the country. Now, in addition to looking at pictures or reading plays or scores, people could study actual productions. Almost everyone in the performing arts,

FOUR OF THE NEARLY 150 EXTANT MAPLESON CYLINDERS RECORDED AT THE METROPOLITAN OPERA HOUSE IN 1901–4.

The New York Public Library for the Performing Arts

The Rodgers & Hammerstein Archives of Recorded Sound

The holdings of the Rodgers & Hammerstein Archives, numbering more than half a million recordings, cover virtually every aspect of recorded sound – from Mozart to Motown to presidential speeches – in every format developed to record sound, including wax cylinders, acetate and aluminum discs, magnetic wire recordings, 78rpm recordings, audiocassettes, and compact discs. Among its many rarities are the items pictured here.

A VOGUE RECORDS PICTURE DISC FEATURING ENRIC MADRIGUERA AND HIS ORCHESTRA, CA. 1946.

The Music Division

Documenting the art of music in all its manifestations – including opera, spirituals, ragtime, jazz, musical comedy, orchestral, rock, and pop music – the Music Division collects both rare scores and manuscripts from the past (shown here are two of its nineteenth-century treasures), as well as works by contemporary composers from around the world. Of particular note is its American Music Collection, for which the division acquires almost every piece of classical and popular music published in the United States each year.

CLAUDE DEBUSSY'S CANTATA *LA DAMOISELLE ÉLUE: POÈME LYRIQUE D'APRÈS D.-G. ROSSETTI* (PARIS, 1893), A COPY OF THE LIMITED-EDITION PIANO-VOCAL SCORE.

The Billy Rose Theatre Collection

The approximately five million items in the Billy Rose Theatre Collection embrace every type of performance, from street corner to stage to studio, including drama and musical theater, film, television, radio, the circus, vaudeville, and puppetry. While the division houses a significant collection of traditional research materials, its strength and uniqueness lie in its unparalleled trove of theater ephemera, as well as in its pioneering efforts to document theater on videotape and film. Among its holdings are the two posters shown here.

JOHN HELD, JR.'S POSTER FOR BELLA AND
SAMUEL SPEWACK'S 1935 PLAY *BOY MEETS GIRL*.

J. SAUDÉ, "TWO COUPLES PERFORMING THE THIRD FIGURE OF THE QUADRILLE." ENGRAVING, CA. 1817.

AUGUSTE BERT'S PHOTOGRAPH OF VASLAV NIJINSKY
AS THE FAVORITE SLAVE IN *SCHÉHÉRAZADE*, CA. 1910

The Jerome Robbins Dance Division

The need to preserve for future researchers the fleeting nature of live dance performances has led the Jerome Robbins Dance Division – the largest and most comprehensive archive of its kind in the world – to collect well beyond traditional formats. The bulk of its holdings consist of nonbook items such as films, videotapes, and audiotapes, as well as prints, original designs, posters, photographs, manuscripts, and memorabilia. From the collection's vast resources, a researcher can, among much else, reconstruct a nineteenth-century quadrille, or determine what makeup Nijinsky wore in *Schéhérazade*.

> I spent all my free time at the Library for the Performing Arts . . . looking at tapes of performances. And the Library became an empowering mechanism. As I struggled and studied, trying to learn my craft as an artist, I would go there and just become enveloped by those visions.
>
> GEORGE C. WOLFE
> *producer of the Joseph Papp Public Theater/New York Shakespeare Festival, at the Library Lions benefit, 1997*

famous and otherwise, knew about the Lincoln Center library, which furnished information and inspiration to innumerable musicians, musicologists, composers, actors, students, writers, directors, scenic and costume designers, moviemakers, choreographers, and dancers.

The third big Library project was the long-discussed central, open-shelf, circulating, college-level library, the "missing link" between the branches and the research libraries. The Mid-Manhattan Library, opened in 1970 on three floors of a department store building on Fifth Avenue and 40th Street, diagonally opposite the central building, was instantly popular. "By Christmas," the branch libraries chief reported, "it

After the renovated Mid-Manhattan Library opened at the corner of Fifth Avenue and 40th Street in 1982, people started to come at the rate of 5,000 a day, and on any given morning crowds of people stood at the entrance waiting for the building to open.

Ethel Waters in
As Thousands
Cheer, *ca.*
1933, from the
Photographs and
Prints Division
of the Schomburg
Center for
Research in
Black Culture.

was standing room only." The Mid-Manhattan Library reached its
fuller potential later, with a renovation and expansion, completed
in 1982, into the entire six-story building. The collections now
encompassed 800,000 volumes (nearly triple the founding collec-
tion in 1970 and including 4,500 magazine titles and the former
Central Circulation holdings from the central building) and the
great Picture Collection. There were a popular general library
on the street floor, subject collections on four floors above, and
the branch system's central offices at the top. The new library
also offered special facilities for disabled persons and a Job
Information Center.

In upper Manhattan, another special Library resource, the
Schomburg Center for Research in Black Culture, had been
evolving into one of the world's largest, most comprehensive,
most used libraries documenting the history, literature, and
art of peoples of African descent. Located in the old 135th
Street Branch building, next to the new Countee Cullen Branch,
it had been treated from the beginning as part of the branch
system, although its collections did not circulate. For a number
of years it had suffered greatly from the lack of funds to catalog
and care for its books, periodicals, pamphlets, photographs,

THE FOUNDING MEMBERS OF THE NIAGARA MOVEMENT (FORERUNNER OF THE NAACP), 1905 (INCLUDING ITS LEADER, W.E.B. DUBOIS, SECOND FROM RIGHT IN THE SECOND ROW).

The Schomburg Center for Research in Black Culture

The collections of the Schomburg Center for Research in Black Culture, some five million items documenting the lives and history of peoples of African descent, are international in scope and range from books, pamphlets, and newspapers, to clippings, sheet music, and sound and video recordings, to paintings and sculpture and manuscripts and archival records. The items pictured here suggest the richness of the historical legacy preserved at the center.

The depths of my memory carry me back to the day when I first entered the doors of the Schomburg Center in Harlem. . . . I was seeking enlightenment and, I must admit, escape from those harsh wintry days that beset me during the chaos of my youth. I recall the book-lined room filled with the kind of knowledge that had eluded me when I was a child in Kansas, where the sordid task of reading books that ignored the artistic and literary contributions of my black forefathers still burns inside me like dry haystack. . . . Thankfully, we now have an institution like the Schomburg, where people of all races and cultures can learn to take measure of talented African Americans who might otherwise be forgotten.

GORDON PARKS
*photographer, filmmaker, and writer,
at the Library Lions benefit, 1998*

clippings, art objects, and artifacts, many of them rare or unique. Still, the Schomburg continued to receive such noteworthy collections as the papers of the Civil Rights Congress, the National Negro Congress, and, later, the records of the organizing committee of the 1963 March on Washington for Jobs and Freedom and the papers of novelist Richard Wright. The rise of the civil rights and black consciousness movements of the 1960s and the advent of black studies programs brought new attention, as well as new acquisitions, to the Schomburg. Collections grew beyond the ability of the existing staff and physical plant properly to deal with them, even as interest and use increased.

African American leaders, intellectuals, and community activists rallied to the Schomburg's cause, winning federal and state grants to make possible the critically needed preservation and organization of its archival materials. And among other ventures, the Schomburg's staff started an Oral History/Video Documentation Project. In 1972, the Schomburg was finally designated a research center, which was clear recognition within the Library of the Schomburg's scholarly significance, on a par with the other research libraries in the system.

DURING THE postwar decades, the research libraries had not only to catch up with acquisitions missed during the war but also to cope with an "information explosion" – the mushrooming world output of publications spurred by the growth of higher education and scholarship, new subjects of study, the rise of the Third World, and huge increases in scientific and technological activity. The task was both daunting and expensive. Nonetheless, the Library remained committed to continuing as best it could the comprehensive collecting that was the research libraries' raison d'être.

As a 1966 fundraising document put it: "Magnificent collections of older materials quickly lose their unique value if not sustained by the continuous comprehensive acquisition of new material. The value of the Library's great collection in any one field of knowledge is enhanced by its association with equally great collections in related fields." Whatever else happened, the quality of the collections, which by 1970 amounted to some four million books and pamphlets and altogether more than fifteen million items, could not be compromised. Other operations might be suspended without permanent loss, but books and serials had to be acquired when available lest they become forever irretrievable.

Even when money was very tight, users could still find just about everything they needed. As usual, political or ideological considerations would not stop the librarians. At the height of the Cold War, they continued to acquire materials from the communist world. In 1948, the Board of Trustees reaffirmed the Library's long-standing policy of acquiring "material on all aspects of the current state of the world and its literature" in order to "enable the scientific enquirer to track the progress of knowledge . . . to the last step." In light of "obstacles to the free flow of ideas that are now being raised in many parts of the world [that] threaten to impair the value of the collections of the Library to its readers," the Director was to continue "the Library's broad policy of uncensored acquisitions."

John and Alice Coltrane, 1966, in a photograph by Chuck Stewart from the Schomburg Center's Photographs and Prints Division.

The Olive Branch Petition, signed by the members of the Continental Congress on July 8, 1775, and sent to King George III as a peace gesture in hope of avoiding war with Britain. One of two original engrossed manuscripts taken to England, it now resides in the Manuscripts and Archives Division.

"Liberty for All,"
New York, 1987,
a poster by George
Stavrinos, from the
International Gay
Information Center
Archives in the
Manuscripts and
Archives Division.

The librarians went on collecting unconventional material –
for example, science fiction (in the 1940s and 50s still considered
unliterary and trashy) and counterculture materials like the "beat"
writings of the 1950s and "guerrilla" art of the 60s – and their
intellectual hospitality and sensitivity to contemporary trends led
to the accumulation of an extensive archive of documents of the
gay and lesbian community in New York and elsewhere. Other
important and often rare items continued to come in, some as
gifts. One was a great treasure of the Library, donated in 1948 by
trustee Lucius Wilmerding – the Olive Branch Petition, addressed
to Britain's George III by the Continental Congress in a last-ditch
effort to avert the American Revolution. In 1961, the Library
received from the estate of trustee George Arents a million dollar
endowment for the Arents Tobacco Collection. First opened in
1944, the collection documented the history of the "filthy weed"
in all and any of its manifestations, including first editions of liter-
ary works and manuscripts in which tobacco is mentioned, such
as a manuscript of Oscar Wilde's *The Importance of Being Earnest.*

Among other notable acquisitions were the papers of promi-
nent public figures such as New York City Parks Commissioner
Robert Moses and Socialist Party leader Norman Thomas;
the correspondence of writer H. L. Mencken; the Oscar Lion

Collection of books, letters, and manuscripts by and about Walt Whitman; prints by Utamaro and Dürer; 16,550 French Revolutionary pamphlets; the earliest illustrated Japanese book; and, for the Berg Collection, T. S. Eliot's typescript of *The Waste Land* and the Virginia Woolf and Sean O'Casey archives.

Writers and scholars working on books requiring extended use of research materials were provided with new amenities. There had been in the past ad hoc arrangements for quiet work places in the central building. (Willa Cather did much of the work for her historical novel *Shadows on the Rock* in such a spot.) But no official, dedicated space existed for the purpose until 1958, when, courtesy of the Ford Foundation, an ornate former small reception room on the main floor was converted into the Frederick Lewis Allen Room, named for the late writer, editor, and Library habitué. Allen had longed for such a place, where writers could keep books on reserve and work in privacy and comfort, complete with desks, bookshelves, typewriters, and reference books (and, later, computer hookups). The Allen Room served as a sanctuary – and also a congenial club for kindred spirits – for the hundreds of writers assigned there through the years and occupying at any one time (and sometimes quarreling over) the eleven carrels. The sources that they called upon to produce novels, histories, biographies, children's books, social and political commentary, art and architecture history, and literary criticism on all sorts of subjects testifies to the Library's extraordinary scope. Several Allen Room books won Pulitzer Prizes: Theodore White's *The Making of the President, 1960*; a new history of New York City, *Gotham*, by Edwin Burrows and Mike Wallace; and biographies of Robert Moses, Peter the Great, and Franklin and Eleanor Roosevelt, by Robert Caro, Robert Massie, and Joseph Lash, respectively. Betty Friedan worked on *The Feminine Mystique* in the Allen Room, and Susan Brownmiller wrote her classic feminist study of rape, *Against Our Will*, there.

All along, people labored on myriad other projects in the main reading room – where, for example, both sides in the landmark *Brown vs. Board of Education* school desegregation case sat preparing their briefs. In 1963, special provision was made there for researchers having to use materials from the central stacks for more than a day or two. Barbara Tuchman, who had done so much of her research at the Library, underwrote a special study and reserve area, the Wertheim Study, named in memory of her father. The Allen and Wertheim rooms were later moved to other locations when the central building was renovated.

"Forbidden Fruit Tobacco," a late nineteenth-century advertisement for the Hill City Tobacco Company, in the Arents Tobacco Collection.

THIS EXTRAORDINARY volume and range of research would have been inconceivable without accurate, up-to-date, and comprehensive catalogs. The larger the collection, the more important and complex such scholarly record keeping becomes. In the 1960s, the chief of the research libraries, James Wood Henderson, realizing the potential of the new computer technology, moved to explore automating the cataloging process. This "gamble," as one administrator called it, paid off: The New York Public Library became the first large general library in the United States to produce a computer-generated catalog, which was initially issued in 1972 in printed book form. In the mid-1980s, the book catalogs were replaced by an electronic catalog named CATNYP (CATalog of The New York Public Library), which eventually made the Library's post-1971 catalog available to users everywhere via personal computers, modems, and the Internet.

The Public Catalog Room (Room 315) in the early 1980s, with volumes from the 800-volume Dictionary Catalog of The Research Libraries of The New York Public Library, 1911–1971 *in the foreground; in the distance is the card catalog, which would soon be removed.*

With the advent of the computer-generated catalog in 1972, the great central card catalog of the research libraries was frozen – that is, new acquisitions ceased to be added to it – although it still had to be consulted for information about pre-1972 holdings. That old catalog was full of dirty, dog-eared, deteriorating cards, some of which, from the Library's earliest days, were handwritten. To preserve these irreplaceable physical records and make the information contained on them available outside the Library, Henderson made it his personal project to have all the cards rehabilitated and reproduced in a published book catalog. Beginning in the 1950s and continuing into the 70s, the new combination of microphotography and photo-offset printing had made possible the publication in book form of many research library catalogs, including those of most of the divisions and certain special collections of The New York Public Library. To do this for the immense central catalog of some eleven million entries (for items in Roman alphabets only) was daunting. But foundation funding was found, and Henderson left his position as chief of the research libraries in 1977 to oversee "Project Retro," which ended in 1983 with the publication of the last volumes of the 800-volume *Dictionary Catalog of The Research Libraries of The New York Public Library, 1911–1971.* This monumental bibliography took its place beside the great catalogs of the Library of Congress, the British Library, and the Bibliothèque nationale de France on the shelves of libraries around the world.

Henderson was also deeply concerned about preserving the collections. The New York Public Library librarians had from the first paid careful attention to the physical care of collections and were pioneers and authorities in the field; by the late 1930s, the Library was a de facto national information center on library microfilming, a preservation approach that gained increasing favor. But it was only in the 1950s that the critical danger to entire collections became dramatically evident. Research showed that almost all materials printed since the late nineteenth century, when wood pulp paper replaced rag paper, faced disintegration due to acidity in the paper and heat and humidity in the air.

This would be a catastrophe for an institution like The New York Public Library, with its huge holdings of nineteenth- and twentieth-century books, journals, newspapers, and unique ephemera, a good many of which were printed on the cheapest, flimsiest paper, not to mention unstable cellulose film and other fragile materials. Not only things like the pamphlets the Library was so proud of, but also early editions of authors like James Joyce and André Gide might be reduced to dust. A good part of our cultural heritage and historical documentation might be lost forever to the "slow fires" of acid, heat, and humidity.

Here again the Library took a leadership role. Henderson established a conservation laboratory, which was subsumed in 1972 into a new Conservation Division (now the Barbara Goldsmith Preservation Division), one of the first comprehensive, coordinated preservation programs in American libraries. The aim was to create optimum physical environments for library materials in all forms, work out ways to prevent deterioration, and treat and restore damaged items. The Library continued on a large scale the preservation microfilming it had earlier begun, explored deacidification processes, and in the 1980s reached an important goal when the central stacks and public rooms and offices were air conditioned. The fires were checked.

MUCH OF this impressive progress, accomplished under the administration of Director Edward Freehafer, took place during a time of fiscal strain. The deficits in the research libraries' budget had become serious and chronic starting in the late 1940s. The Library's main resource, the endowment, had remained static and did not generate the steady stream of new money necessary for a dynamic, growing institution. High prices for just about everything, growing user demands, space needs, deteriorating book

stock, and rising labor costs exacerbated the situation. And the "information explosion" meant that there were many more books and journals to get – at steeply rising prices.

The Library embarked upon modern, professional, fundraising, far beyond the trustees' former quiet personal appeals and negotiations, and administrators initiated cost-effective management. Still, incoming funds, public and private, did not substantially reduce the deficits. Rates of library growth were geometric and funding rates arithmetic, a dilemma faced by research libraries generally.

The New York Public Library was in a unique position. It encompassed one of the greatest American research collections and had the highest rate of use; its vast holdings were open freely to anyone and everyone; it served local businesses and countless university students and faculty members from all over; it was the core of New York City library resources, vital to the city's place in American life. Yet by its nature the Library had no distinctive constituency, and people were often confused about its dual reference-circulation structure and complex sources of funds. The "Public" in its name expressed the Library's philosophy but gave the impression that it was an entirely publicly financed municipal institution. At the same time, the fact that it was also privately supported and an independent corporate entity made it somewhat difficult to explain the need for public funds. Yet the Library persevered – continuing to serve the varied public and private interests that it always had, and against all odds.

By the late 1960s and into the 70s, the odds had become greater. Double-digit inflation and a looming economic recession, in the midst of the expensive, unpopular Vietnam War, were bringing fiscal retrenchment to all levels of American government and to cultural and educational establishments. New York City, heavily in debt, would by the mid-1970s teeter on the brink of bankruptcy.

In 1969, the trustees made a difficult decision. They agreed that the Library would "continue to acquire and catalog books and other materials as its obligation to remain one of the world's major research libraries and to support the advanced reference and research needs of the New York academic, business, and professional community." Instead, hours of service at the central building would be reduced, a policy "incompatible with the ideals of libraries" and adopted with "extreme grief and deep concern." Public reaction from celebrities, intellectuals, and civic leaders produced some financial relief from public and private sources, but not enough. The Library was soon forced to close the central

building on Sundays, holidays, and evenings (and, later, even one weekday); cataloging backlogs built up and maintenance suffered.

In the branch libraries, public protests averted the severe cuts proposed by the city in 1970, but municipal cutbacks and job freezes during the city's very deep crisis in the mid-1970s forced staff layoffs and reductions in hours. At the same time, the need for neighborhood library service grew, as it always did in hard times. Poor people and their children depended on libraries as quiet cultural havens and sources of free information and help with homework and other pursuits, especially as budget cuts devastated school libraries.

An American Council of Learned Societies report urging substantial government and foundation contributions to the Library put the issue succinctly. "We are confronted here with the question of how to sustain and develop a great institution of imponderable worth to our culture, when everyone uses it but no one is specifically responsible for its support." The Library would manage to answer that question and in the process would emerge stronger and more popular than ever.

A conservator removing old rebinding adhesive on the sixteenth-century Towneley Lectionary in the Barbara Goldsmith Conservation Laboratory, 1996.

"A Metaphor
for an
Ideal City"

Creating a 21st-century Library

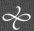

Facade of the central building at Fifth Avenue and 42nd Street, lit at night.

I N 1997, Nobel Prize laureate and Library trustee Toni Morrison extolled The New York Public Library: "What distinguishes it among public institutions is that it seems to have taken for its guiding principle: 'only the finest of everything is good enough for the least of us.' . . . The posture of The New York Public Library is, and must continue to be, that the public trust deserves the best: the greatest collections, the most sophisticated tools, the most enlightening exhibits, the strongest network of its branches, the most faithful and elegant restoration." This tribute precisely expressed the Library's abiding ethos, an ethos that underlay its remarkable recovery from difficult years.

The Library embarked upon a vigorous campaign to raise consciousness within the city of public libraries' crucial importance to democratic cultural and educational life. Always connected to the people it served, the Library now turned those ties into political and financial capital to protect itself during hard times and to expand during prosperity. A partnership with the city (and the state) was forged, Mayor Edward I. Koch later wrote, "and, in a

Brooke Astor, a great benefactor of the Library, in June 1998, at Entr'acte, *an event celebrating the start of the renovation of the Library for the Performing Arts.*

less formal way, with the people of the City of New York – who quickly became relentless advocates for the Library." Astute fundraising and public relations campaigns that focused on plans for the Library's future raised a great deal of money from private as well as city, state, and federal sources. The Library moved from survival to stability and on to great strength – allowing for the launching of a succession of projects that solved long-standing problems and brought both research and branch libraries into the 21st-century world of high information technology.

THE PROCESS had begun in 1971 under a new chief executive officer, now designated president, Richard Couper. Beginning in 1974, new board leadership, led by Honorary Chairman of the Board of Trustees Brooke Russell Astor, mobilized the trustees and other New Yorkers to work for and to donate to the Library as never before. Mrs. Astor was the widow of Vincent Astor, a descendant of the Astor Library's founder and a longtime trustee of The New York Public Library. After his death in 1959, she assumed control of the Vincent Astor Foundation, whose assets were to be used "for the alleviation of human misery." Focusing mainly on New York, the foundation under Mrs. Astor sub-stantially assisted the city's great cultural institutions as well as community-based projects. For her indefatigable work for the people of the city, her charm and enthusiasm, and her leadership in society (which she used to advantage in pursuing her cultural and community concerns), *The New York Times* called Mrs. Astor "New York's unofficial First Lady." The New York Public Library

was her favorite charity, one of the city's "crown jewels" for which she felt a special affection and family obligation.

Led first by Mrs. Astor and the board chairman that she recruited, New York businessman Richard B. Salomon, and then in 1981 by a new team – board chairman Andrew Heiskell, former chairman of Time, Inc., and a new president, the dynamic Armenian-American scholar, teacher, and university administrator Dr. Vartan Gregorian – this crusade for the Library tapped fresh sources of interest, energy, and money, public and private. Gregorian and the trustees advanced an ambitious agenda that reaffirmed the Library's regional and national importance as an irreplaceable intellectual resource.

The results were spectacularly successful. Under Gregorian's active leadership, the expanded Mid-Manhattan Library opened, and the Schomburg Center finally got its new building and then set about renovating its landmark old building to house its special collections. Lost hours of service in both research and branch libraries were largely restored, four new branches were built, and the Library's deficit was erased and the endowment augmented – the result of the city's economic recovery, community activism, private giving, and lobbying efforts. The most visible sign of renewal was the plan to refurbish and modernize the central building. The two main exhibition halls (which had been converted to offices) were restored to their former elegance and, now renamed the D. Samuel and Jeane H. Gottesman Exhibition

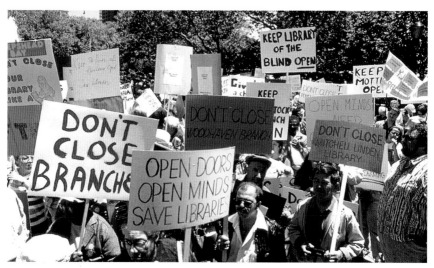

Budget rally for New York City's libraries, June 13, 1991.

The Langston Hughes Lobby at the new Schomburg Center, showing the floor's inlaid "cosmogram," Rivers, *a terrazzo and brass art work inspired by Hughes's poem "The Negro Speaks of Rivers."*

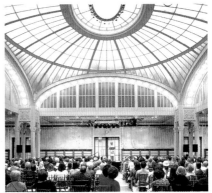

The Celeste Bartos Forum on Centennial Day, May 20, 1995.

Hall and the Edna Barnes Salomon Room, were returned to their original purpose, housing major exhibitions highlighting the Library's collections. The former Central Circulation room on the ground floor, with its great glass and steel ceiling and marble walls, metamorphosed into the new Celeste Bartos Forum, the setting for public lectures and panel discussions. The public catalog room was renovated to accommodate the public computer terminals that provided access to CATNYP, the electronic catalog. The third-floor rotunda, with its murals by WPA artist Edward Laning, was restored as the McGraw Rotunda through a gift from Harold W. McGraw, Jr., the refurbished DeWitt Wallace Periodical Room opened, and funds were donated to create the

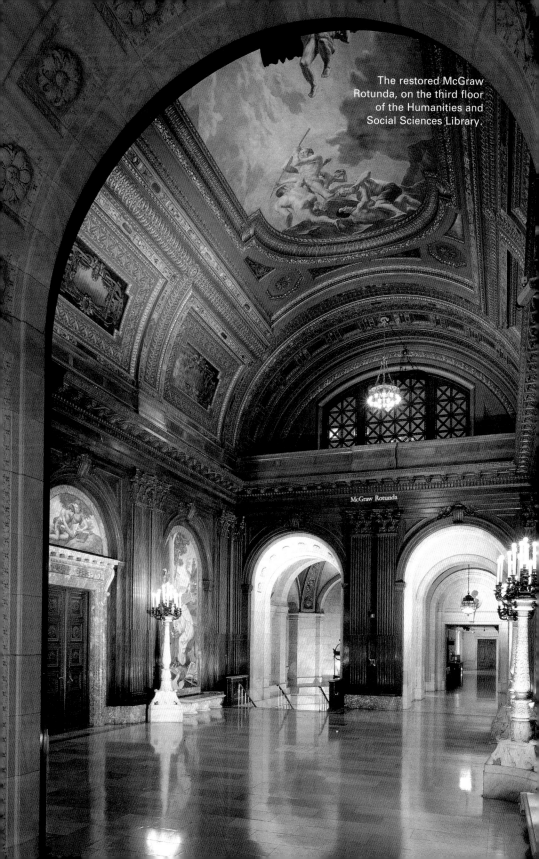

The restored McGraw
Rotunda, on the third floor
of the Humanities and
Social Sciences Library.

McGraw Rotunda

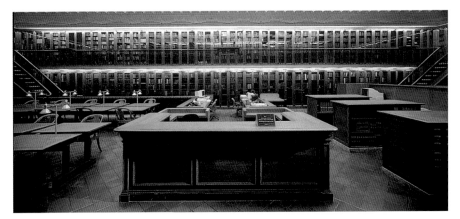

*The Brooke Russell Astor Reading Room for Rare Books
and Manuscripts.*

new Brooke Russell Astor Reading Room for Rare Books and
Manuscripts (which opened in 1993). The city restored and
cleaned the building's facade and re-landscaped the Fifth Avenue
Plaza. And plans went forward for the city to construct under
Bryant Park a long-dreamed-of extension of the book stacks to
store some 3.5 million volumes (doubling the capacity of the
original stacks).

Above ground, another transformation would complement
the Library's face-lift and give midtown a great new amenity.
Bryant Park had become a dangerous hangout for drug dealers
and thieves, not to be entered by ordinary people by day or
night. Andrew Heiskell determined to reclaim the park for the
people and for the well being of the Library. The Bryant Park
Restoration Corporation, founded by Heiskell, refurbished the
whole area, and when it reopened in 1992, the park had been
transformed into a safe and comfortable spot for strolling, sitting,
eating, and enjoying free concerts and other entertainment, with
the handsome rear facade of the Library as backdrop.

IN 1989, Gregorian left the Library to return to academe as
president of Brown University. The Library trustees appointed
in his place Dr. Timothy Healy, former president of Georgetown
University, an erudite and eloquent scholar and teacher, and a
Jesuit priest committed to serving the poor. His tenure as Library
president was fruitful but brief; he died suddenly in 1992.

During Dr. Healy's time, the Library undertook an important strategic planning initiative, under the committee leadership of Trustee Samuel C. Butler (who would be appointed Chairman of the Board in 1999), which shaped the Library's plan for its second century of service. Also during Healy's tenure, the state-funded Andrew Heiskell Library for the Blind and Physically Handicapped, a spacious new facility, opened at the end of 1991. The library, named for the man who spearheaded the efforts to get it built, set a new standard of library service for persons with disabilities. It was architecturally barrier free, and patrons could listen to audiorecordings privately and comfortably and take advantage of new technology that could greatly enlarge print. A state-of-the-art computer-guided conveyor system speedily handled the large volume of recorded and braille books that were mailed to individuals, schools, and institutions.

Like many other American public libraries trying to meet new needs with limited resources, the branches moved toward new public-private partnerships. In 1991, under the leadership of trustee Marshall Rose, the Library inaugurated Adopt-A-Branch, a program that paired private gifts with city funds to renovate branches and help revitalize imperiled neighborhoods. By 1999, thirteen branches had been adopted. Each reopening

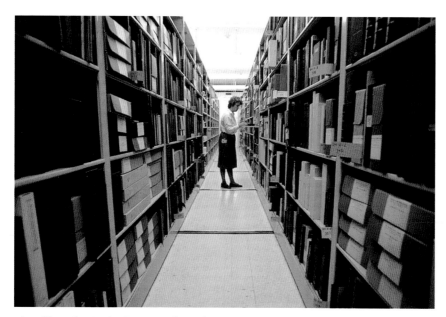

A staff member in the Bryant Park Stack Extension.

The Carl H. Pforzheimer Collection of Shelley and His Circle

One of the world's leading repositories for the study of English Romanticism, the Pforzheimer Collection encompasses some 20,000 items, including books, manuscripts, letters, and other objects, chiefly from the late eighteenth and early nineteenth centuries. Among the materials documenting the circle of family and friends surrounding the poet P. B. Shelley and his wife, Mary Wollstonecraft

RUDYARD KIPLING, "TIED UP IN TAILS! (OR TALES) OR IS IT TALES OF TAILS?" PEN-AND-INK SKETCH FOR HIS BOOKPLATE, SIGNED WITH INITIALS, N.D.

E. E. CUMMINGS. POSTER-SIZED BIRTHDAY CARD FOR HIS WIFE, MARION MOREHOUSE. OIL ON CARDBOARD, SEPTEMBER 1949.

VIRGINIA WOOLF. DIARY. AUTOGRAPH NOTEBOOK, 1920.

VLADIMIR NABOKOV, "NOTES ON THE MORPHOLOGY OF THE GENUS LYCAEIDES: ON THE EVOLUTION OF WING PATTERNS." SCRAPBOOK WITH PEN-AND-INK DIAGRAMS AND NOTES, CA. 1943–48.

The Henry W. and Albert A. Berg Collection of English and American Literature

The Berg Collection is celebrated for its first editions, rare books, autogra
etters, and manuscripts, and is especially strong in nineteenth- and twen
century literature. Shown above are items from the Virginia Woolf and Vla
Nabokov archives, and from distinguished caches of material by and abo

The Andrew Heiskell Library for the Blind and Physically Handicapped, at 40 West 20th Street, in Manhattan's Chelsea neighborhood.

Children using computers at the June 11, 1996, reopening of the West Farms Branch Library in the Bronx, which was restored as part of the Library's Adopt-A-Branch program.

was a gala affair for the community. In one handsome old restored Carnegie branch, Morrisania in the South Bronx, attendance and circulation tripled within months of its reopening. Also in 1991, an innovative outreach program, the Connecting Libraries and Schools Project (CLASP), began operation in several branches with seed money from the DeWitt Wallace–Reader's Digest Fund. This project, later extended to Queens and Brooklyn, aimed to actively cultivate the reading and library habit in children, especially in light of cutbacks in school library service. CLASP librarians went out into the schools and the community to encourage children and their family members to sign up for library cards and learn about books and the library.

Librarians also began to reach out to others in the community who were not normally library users. In a new focus on very

Summertime story-telling hour at the Hans Christian Andersen statue in Central Park, July 28, 1999, one of the many programs presented by the Office of Children's Services.

young children, an Early Childhood Resource and Information Center opened in a Greenwich Village branch in 1978. The Library also served homeless adults and children living in shelters and supplied reading materials to prison populations. Centers for Reading and Writing offered adult literacy instruction in English and Spanish.

In the new wave of mass immigration to the United States in the 1980s, this time from the Caribbean and Latin America, Asia, and Africa, New York City was again amazingly polyglot. Depending on the neighborhood ethnic composition, Library branches began again to house substantial non-English-language collections in addition to the Donnell Library's World Languages Collection, which had grown to nearly 150,000 books and many magazines in some eighty languages. Selected branches collected Spanish, Chinese, Italian, French Creole, Hebrew, Korean, Polish, Russian, and Vietnamese materials; and several branches, designated Ethnic Heritage Centers, stocked more extensive collections on the history, culture, literature, and geography of African American, Italian, Chinese, and Hispanic peoples. All the branches

offered multicultural programs, and some held free classes in English for speakers of other languages (ESOL). These were so popular that registration had to be by lottery. ESOL went online in 1996 with a computer-assisted program in the Aguilar Branch Library's Language Learning Center. In the first two months, more than 1,500 persons logged on; the languages they spoke most often were Spanish, French, Chinese, Russian, and Korean.

The branches also evolved as multimedia centers, stocking films, videotapes, audiocassettes, and compact discs as the formats became widely available. The famous Donnell Library film collection expanded into the Donnell Media Center, one of the largest of its kind in the United States and including a Film/Video Study Center. Besides nearly 10,000 films and extensive audio holdings, the Media Center carried videotapes ranging from popular releases to video art to independently produced documentaries and exemplary television programs.

IN THE mid-1990s, when New York City was vibrant and solvent again with a thriving economy, new leadership accelerated the momentum that had brought the Library renewed prominence and prestige. President Healy's successor, Dr. Paul LeClerc, appointed in 1993, was an energetic and far-sighted scholar, teacher, and university administrator – a Voltaire specialist and president of Hunter College of the City University of New York.

LeClerc, the trustees, and the staff moved to position the Library to offer the public the latest in universal information access. They aimed to equip the entire Library with electronic links not only to its own collections but, through the increasingly powerful Internet, to collections, bibliographies, and information all over the world.

An unprecedented meeting of world library leaders, convened by LeClerc in April 1996 as the capstone of the Library's Centennial year, explored this concept. The directors of some fifty national, university, and public libraries on five continents discussed "Global Library Strategies for the 21st Century." The extraordinary mix of institutions symbolized the mission of The New York Public Library – the commitment to scholarly and popular use, to supporting all levels of education, and to

OPPOSITE *Cover of the May 22, 1995, issue of* The New Yorker *by Edward Sorel, celebrating the Centennial of The New York Public Library.*

A sound-and-
light show
dramatizing the
Library's past,
present, and
future was part of
the illumination
ceremony in front
of the Library on
Fifth Avenue and
42nd Street on
Centennial Day,
May 20, 1995.

maintaining its global reach and the multiethnic, multilingual character of its collections and services. And the consensus that libraries would endure not only as keepers of books and all the other materials they had always collected, but as centers for public access to electronic information and guidance in its use, expressed the outlook of The New York Public Library.

This outlook was exemplified by a grand new undertaking – the construction of a high-technology, combined circulating and reference complex, the Science, Industry and Business Library (SIBL), in a landmark former department store on Madison Avenue and 34th Street. In planning SIBL, the Library's board chairman at the time, real estate developer Marshall Rose (who as chairman had already played a key role in the Bryant Park Stack Extension and in the restoration and renovation of several research and branch libraries), was instrumental in forging a creative financing arrangement for the $100 million project among New York State, New York City, and federal and private sources. All of these entities were persuaded of the value of business, science, and technology information resources to the city's economic and social health. Designed by the architectural firm Gwathmey Siegel & Associates, the 160,000-square-foot library,

BUILDING LIBRARIES IN A NEW WORLD, 1945–2000

sleek and elegant, combined resources in science, technology, and business from the central building with the collections in those subjects from the Mid-Manhattan Library to form the nation's largest public information center devoted to science and business. It housed a research-level collection of 1.2 million volumes, numerous microforms, and a circulating library of 40,000 books and videos, over 10,000 current business and scientific serial titles, an open-shelf reference collection of 60,000 volumes, and comprehensive collections of United States and foreign documents, patents, local laws, New York City information, and demographic data.

Beyond that, SIBL was an information age showplace, the epitome of modern information service. Tables were wired to support up to 500 laptop computers, and the Elizabeth and Felix Rohatyn Electronic Information Center, with seventy-three workstations, provided access to all sorts of electronic resources – New York Public Library catalogs (CATNYP and the branch libraries' new system, LEO [Library Entrance Online]), Internet databases, CD-ROMs, electronic journals, and online services. People anywhere could search for and request information about SIBL and the resources of the entire New York Public Library through the Internet twenty-four hours a day. Specialist librarians helped users find what they needed, and an Electronic Training Center offered individual and group instruction in using elec-tronic information. Two special information services targeted key aspects of New York City's economy – the Small Business Information Service and the International Trade Resources

Extensive collections of periodicals in science, technology, and business distinguish SIBL as a preeminent research library in these disciplines. The Revue de l'énergie *is among the many non-English-language journals in its collections.*

THE GLASS-AND-STEEL ELEVATOR CAB IN HEALY HALL.

The Science, Industry and Business Library

The transformation of part of an early twentieth-century landmark, the B. Altman department store at Fifth Avenue and 34th Street, into a library for the next century – the architecturally visionary Science, Industry and Business Library – was the work of architects Gwathmey Siegel & Associates. Opened in 1996, SIBL is one of the nation's most technologically sophisticated business and science libraries.

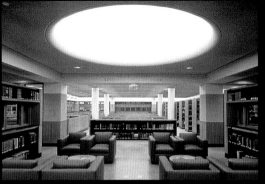

The Richard B. Salomon Research Reading Room (left) offers a combination of open-shelf book collections and wiring for laptop computers, as well as comfortable seating for readers. Below, the circulation desk facing Healy Hall, the 33-foot-high atrium named in memory of former Library president Timothy Healy.

THE RICHARD B. SALOMON RESEARCH READING ROOM.

CIRCULATION DESK.

This recently endowed division moved to more spacious and renovated quarters in 2000. Its holdings are used each year by thousands of scholars, students, politicians, city planners, television and film producers, and members of the general public, many of the latter researching their family history in the division's extensive genealogical materials (including the coats-of-arms shown here).

Dungan

Bonnell

WAPPEN
der Edeln Herren und Grafen zu
EULENBURG.

MAGYARORSZÁG CZIMERE

(KIS CZIMER.)

Center. All these services, offered free of charge, were developed to address the information needs of people with differing levels of technological sophistication, information-seeking skills, and educational and social backgrounds. In this spirit, SIBL also initiated a Science Education Program for teachers and students at local high schools. And for clients willing to pay for librarians to do their research for them, there was NYPL Express Information Services, a unit in the research libraries that for a fee supplied such value-added in-depth service.

By the time SIBL opened in 1996, the research libraries had been organized into four research centers: the Humanities and Social Sciences Library (in the big Fifth Avenue building, which remained the Library's central administrative headquarters); The New York Public Library for the Performing Arts (at Lincoln Center); the Schomburg Center for Research in Black Culture, uptown in Harlem; and SIBL on Madison Avenue. The relocation of large collections to SIBL meant that more thoroughgoing reorganization of space in the central building could be undertaken and its restoration and modernization completed.

The grandest project was the return to its original splendor of the great main reading room, which had become dingy and overcrowded with equipment. The restoration, which took sixteen months, was financed by trustee Sandra Priest Rose and her husband, real estate developer Frederick Phineas Rose, and named, in honor of their children, the Deborah, Jonathan F. P., Samuel Priest, and Adam Raphael Rose Main Reading Room. Reopened in 1998 to much applause, the Rose Main Reading Room glistened under the gilded ceiling reminiscent of the basilica of S. Maria Maggiore in Rome. The carefully restored or reproduced tables, chairs, and lamps shone in the clear light of newly cleaned windows and sparkling chandeliers. "Even on the gloomiest days," *The New York Times* reported, "the library's Main Reading Room glows." Longtime users were thrilled. "It's fabulous, just fabulous," a writer raved. "This is the Versailles of New York."

But it was a palace for the 21st century. Most of the tables were wired for computer use by cleverly hidden electronic connections, and a bank of tables was outfitted with electronic workstations for access to electronic catalogs and databases. (Such workstations had earlier been installed in the adjoining Bill Blass Public Catalog Room, courtesy of a generous gift

For almost five years I had worked toward the book [*On Native Grounds, 1942*] in the great open reading room, 315, of the New York Public Library, often in great all-day bouts of reading that began when the place opened at nine in the morning and that ended only at ten at night. . . . Year after year I seemed to have nothing more delightful to do than to sit much of the day and many an evening at one of those great golden tables acquainting myself with every side of my subject. Whenever I was free to read, the great Library seemed free to receive me. Anything I had heard of and wanted to see, the blessed place owned.

ALFRED KAZIN
New York Jew (1978)

from the fashion designer, a Library trustee and longtime benefactor.) A redesigned and unobtrusive photocopying enclave replaced the old service, and the microfilm readers were relocated to another room. Architectural critic Paul Goldberger observed that the exquisitely restored reading room was "a metaphor for an ideal city – a place that incorporates change while holding on to everything that made it so beloved, a place where a wildly diverse group of inhabitants are thrown together within something vast and monumental and left to achieve their private goals, communally."

The New York Public Library had always functioned in effect like a scholarly academy. Beginning in 1999 it would also do so in a more formal way. A gift in honor of Brooke Astor from trustee Dorothy Cullman and her husband, Lewis, patrons of the arts and education in New York, created the Center for Scholars and Writers in the Humanities and Social Sciences Library. This fellowship program, under the leadership of founding director Peter Gay, Sterling Professor of History Emeritus at Yale University, provides stipends, research facilities, and services to up to fifteen scholars and creative writers each year. During their year-long residency, Fellows work on a project and participate in the Center's activities – lectures, colloquia, readings, symposia, and conferences.

At Lincoln Center, there began a complete interior renovation of the Performing Arts Library building, to be named the Dorothy and Lewis B. Cullman Center in recognition of the Cullmans' great leadership gift for the project. The $30 millon renovation, designed by the architectural firm Polshek and Partners, will make cross-disciplinary research easier, reflecting the collaborative nature of the performing arts. The Lincoln Center complex, which had suffered a good deal during the economic downturn of the 1970s, experienced a renewal in the 1980s and 90s along with the city's and the entire Library's resurgence. Grand gifts came in: the Toscanini Legacy, an archive of Toscanini's marked scores, letters,

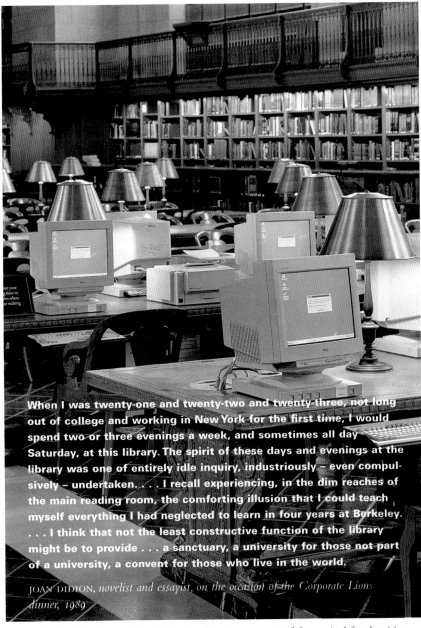

When I was twenty-one and twenty-two and twenty-three, not long out of college and working in New York for the first time, I would spend two or three evenings a week, and sometimes all day Saturday, at this library. The spirit of these days and evenings at the library was one of entirely idle inquiry, industriously – even compulsively – undertaken. . . . I recall experiencing, in the dim reaches of the main reading room, the comforting illusion that I could teach myself everything I had neglected to learn in four years at Berkeley. . . . I think that not the least constructive function of the library might be to provide . . . a sanctuary, a university for those not part of a university, a convent for those who live in the world.

JOAN DIDION, *novelist and essayist, on the occasion of the Corporate Lions dinner, 1989*

Restored oak tables in the Rose Main Reading Room, most of them wired for electricity and data transmission, with lines running through seven stack floors directly into the pedestals. Library patrons can now connect laptops, as well as access a wide range of electronic databases at numerous computer workstations, and even explore the World Wide Web.

WINGED FEMALE FIGURES DECORATE THE CEILING.

A GILT CHERUB ON THE CEILING.

The Deborah, Jonathan F. P., Samuel Priest, and Adam Raphael Rose Main Reading Room

The luminous restoration of the Main Reading Room, completed in 1998, was a milestone in the effort to reclaim the Library's interior spaces from the tarnishing effects of time and use, and to introduce the information technologies of the future. Under the direction of Davis Brody Bond, the sixteen-month project involved the labor of hundreds of craftsmen, who removed the World War II blackout paint from the windowpanes; repainted the ceiling murals; and refurbished, cleaned, glazed, gilded, and restored every surface to its original brilliance. Finally, the room was invisibly wired for the 21st century. At the opening ceremony on November 12, 1998, President Paul LeClerc said, "The Rose Main Reading Room is the symbolic heart of the Library, the place where the library's democratic ideal is wholly realized. As such, it is a special privilege to see the room returned to its original glory."

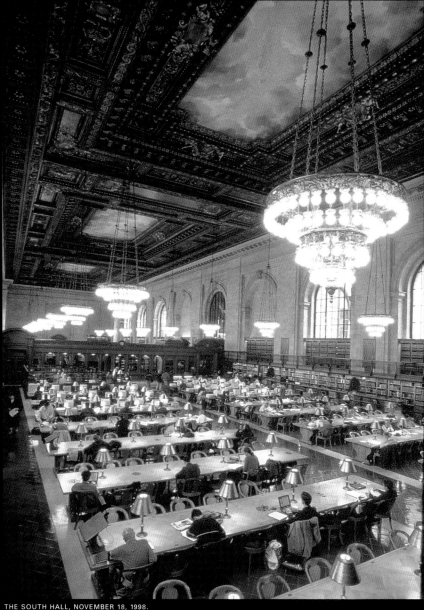

THE SOUTH HALL, NOVEMBER 18, 1998.

and other memorabilia; the John Cage Memorial Manuscript Collection; the voluminous Joseph Papp/New York Shakespeare Festival Archive; the Lillian Gish Archive; the Vaslav Nijinsky diaries; the papers and theater set designs of Donald Oenslager; the Agnes de Mille Papers; the artistic archives of Jerome Robbins; and the Rudolf Nureyev Collection – to name some of the most outstanding.

The other research libraries also attracted wonderful gifts of materials during the flourishing 1990s. Just to mention a few among very many: the Oriental Division received 300 volumes on Buddhism, and the Slavic and Baltic Division added Czech avant-garde books published in the 1920s and 30s and the Batkin Archives on the Russian civil war. The Spencer Collection received sixty books illustrated by Maurice Sendak, and to the Berg Collection came Henry James letters, W. H. Auden correspondence, and the Vladimir Nabokov Archive. The Manuscripts and Archives Division acquired the archives of Yaddo, the artists' community; *The New Yorker* donated to the Library its records, from 1925 to 1980; the firm of J. P. Morgan gave SIBL a hundred cartons of books on banking from 1920 to 1990; and the Schomburg Center received the Ralph Bunche Family Archive and the papers of actors Ossie Davis and Ruby Dee and of the prominent Congressman William H. Gray III.

> In the past century, the Library has acquired many documents, objets d'art, and bibliographical baubles that justifiably emboss its reputation: a 1493 copy of Columbus's letter announcing his discovery of the New World; Jefferson's handwritten copy of the Declaration of Independence; Washington's final draft of his Farewell Address; the first Gutenberg Bible to cross the Atlantic; Eliot's manuscript of "The Waste Land," with Pound's marginal comments. There are Talmuds and penny dreadfuls, a ninth-century Koran and nineteenth-century baseball cards. But it is the Reading Room, Room 315, that is the Library's supreme treasure. This is not a museum; it is an inclusive – *wildly* inclusive – house of knowledge and art and information.
>
> DAVID REMNICK
> *"Room 315 at 100,"*
> The New Yorker, *May 22, 1995*

UNDERPINNING MANY of these post-Centennial accomplishments was the Library's successful "Second Century Campaign," initiated by the Board of Trustees under the chairmanship of Marshall Rose and continued by his successors, Elizabeth Rohatyn and Samuel C. Butler, to gain major public and private support for the creation of a "21st-century library." Among other new plans under way was the first significant above-ground addition to the central

building, an ingeniously designed structure within an unoccupied interior courtyard that would house offices, an auditorium, and, most important for the public, a center for free training in the use of electronic resources. The Library also entered into a new venture to deal with the perpetual issue of space for research collections, given the continued addition annually of some 100,000 items. Together with Columbia and Princeton universities, the Library planned a cooperative, climate-controlled facility in suburban New Jersey for materials in low demand, with provision for electronic access and quick delivery to users.

In his effort to make The New York Public Library's collections universally useful, LeClerc obtained the considerable federal and other funding required for the conversion to digital form of the eleven million author, title, and subject entries that made up the 800-volume 1911–71 catalog. The records of nearly all the Library's research holdings, past and present, would then be available online at the Library and through the Internet, an extraordinary boon for scholars and researchers everywhere.

One of the great soaring windows – looking west – in the South Hall of the Rose Main Reading Room.

Along with many other large American libraries, the Library had established a presence on the Internet in 1995 with its website (www.nypl.org). Continually evolving and expanding, in 1999 the site attracted over three million users from Australia to Zimbabwe. It provides a far-reaching venue for information about the Library, its collections, services, special events, exhibitions, and publications, as well as fast, convenient access for users anywhere to the Library's electronic catalogs, CATNYP and LEO, and numerous electronic databases.

The website also includes something quite new – digitized texts and images from the Library's collections. The Digital Library Collections debuted with Digital Schomburg, a selection of rare nineteenth-century images and texts from the Schomburg Center. Additional collections are continually being digitized,

both to preserve the materials and to disseminate them on the World Wide Web.

To support these electronic activities as well as internal operations, the Library has invested in a state-of-the-art high-speed fiber optic cable network. And on the national and international library scene, it has spearheaded, together with the Bibliothèque nationale de France, ongoing discussion of collaborative strategies to manage digital library collections.

THE LIBRARY remains an ever-growing archive of the human record, in a new technological context. Textual and graphic materials are still being produced and collected, but in electronic as well as traditional formats, and access to them is increasingly achieved through both electronic and print sources. The New York Public Library will continue to "build a future for our past" in this new environment, inspired, as always, by its democratic ethos.

FURTHER READING

Dain, Phyllis. *The New York Public Library: A History of Its Founding and Early Years* (New York, 1972).

Davidson, Marshall B., in collaboration with Bernard McTigue. *Treasures of The New York Public Library* (New York, 1988).

Dierickx, Mary B. *The Architecture of Literacy: The Carnegie Libraries of New York City* (New York, 1996).

Lydenberg, Harry Miller. *History of The New York Public Library, Astor, Lenox and Tilden Foundations* (New York, 1923).

Reed, Henry Hope. *The New York Public Library: Its Architecture and Decoration* (New York, 1986).

Sam P. Williams, comp. *Guide to the Research Collections of The New York Public Library* (Chicago, 1975).

ILLUSTRATION CREDITS / PERMISSIONS

This list includes items in the collections of The New York Public Library and elsewhere. Information in parentheses is in addition to that supplied in the captions for each image. The Library gratefully acknowledges the authors, photographers, agents, and publishers for their permission to use copyrighted material in *The New York Public Library: A Universe of Knowledge*. Every reasonable effort has been made to obtain all necessary permissions. Should any errors have occurred, they are inadvertent, and every effort will be made to correct them in subsequent editions, provided timely notification is made to the Library in writing.

The Branch Libraries

Central Children's Room, Donnell Library Center: 66 (Reprinted with the permission of Atheneum Books for Young Readers, an imprint of Simon & Schuster Children's Publishing Division, from *Kidnapped* by Robert Louis Stevenson, illustrated by

N. C. Wyeth. Copyright 1913 Charles Scribner's Sons; copyright renewed 1941
N. C. Wyeth), 68 (Mireille Levert. *Little Red Riding Hood.* Toronto: Groundwood
Books/Douglas & McIntyre, 1995. Copyright © 1995 by Mireille Levert. Published
by Groundwood Books/Publishers Group West; *Red Riding Hood.* Retold by
Beatrice Schenk de Regniers. Drawings by Edward Gorey. New York: Atheneum,
1972. Reprinted with the permission of Atheneum Books for Young Readers,
an imprint of Simon & Schuster Children's Publishing Division. Illustrations
copyright © 1972 Edward Gorey; Walter Crane. *Little Red Riding Hood.* London &
New York: John Lane, n.d.; Charles Perrault. *Fairy Tales.* Illustrated by Charles
Robinson. London: J. M. Dent & Sons Ltd., 1913), 69 (*The Fairy Tales of Charles
Perrault.* Illustrated by Harry Clarke. London: George G. Harrap & Co., Ltd.,
1922), 71; **Picture Collection, Mid-Manhattan Library**: 77 (copyright © Art Spiegelman,
1995); **World Languages Collection, Donnell Library Center**: 92

Humanities and Social Sciences Library

Arents Tobacco Collection: 38 (Goulston Baseball Collection, Scrapbook No. 5), 107;
**Art and Architecture Collection, Miriam and Ira D. Wallach Division of Art, Prints and
Photographs**: 39 (Plate 31 in *Der Decor: Zierungen für's Kunstgewerbe.* Vienna: Fried.
Wolfrum, ca. 1910); **Carl H. Pforzheimer Collection of Shelley and His Circle**: 120; **Dorot
Jewish Division**: 52; **General Research Division**: 34, 37 (*Weird Tales*; cover by C. C.
Senf. © Weird Tales, Ltd.), 56–57 (© 2000 Estate of Reginald Marsh/Art Students
League, New York; © 1929. The New Yorker Magazine, Inc.), 125 (Reprinted
by permission; Copyright © 1995 The New Yorker Magazine, Inc. All rights
reserved); **Henry W. and Albert A. Berg Collection of English and American Literature**:
58 (William Makepeace Thackeray's self-portrait, with portraits of George
Cruikshank, Charles Dickens, William Henry Brookfield, and Mrs. Brookfield.
Pencil with oil on ivory, n.d.), 121 (birthday card by E. E. Cummings © by the
E. E. Cummings Copyright Trust. Reproduced by permission; Virginia Woolf
diary from the Virginia Woolf Archive. Used with permission of the Society
of Authors, as the literary representative of the Estate of Virginia Woolf; Vladimir
Nabokov notebook from the Vladimir Nabokov Archive. Courtesy of the Estate
of Vladimir Nabokov); **Irma and Paul Milstein Division of United States History, Local
History and Genealogy**: 37 (George E. Tewksbury. *The Kansas Picture Book.* Topeka:
A. S. Johnson, 1883), 130; **Manuscripts and Archives Division**: 16 (Book of Hours,
De Ricci 47; *Lectionarium Evangeliorum,* ca. 970, De Ricci 1; Towneley Lectionary,
ca. 1550–60, De Ricci 91), 17 (Washington's Farewell Address), 36 (Babette Deutsch
Papers), 61, 104, 105 (International Gay Information Center Archives, Gift of
Lambda Legal Defense and Education Fund, Inc. © Lambda Legal Defense and
Education Fund, Inc.); **Map Division**: 45 (*Londini Angliae. . . .* Map by Joannes De
Ram, Slaughter #1214; "The Right Ascension and Declinations of the Principal
Fixed Starrs. . . ." From John Seller's *Atlas Maritimus,* Slaughter #317); **Oriental
Division**: 43; **Photography Collection, Miriam and Ira D. Wallach Division of Art, Prints and
Photographs**: 1, 27, 35 (photograph by Underwood & Underwood), 42, 79 (Near
the Beach at Eltingville, ca. early 1920s. From the album *Pictorial Review of the
Work of the Staten Island Office of Extension Division*; photograph by Percy Sperr);
Print Collection, Miriam and Ira D. Wallach Division of Art, Prints and Photographs: 46–47;
Rare Books Division: 17 (Gutenberg Bible), 31 (dime novels: Edward L. Wheeler.
Hurricane Nell, the Girl Dead-Shot; or, The Queen of the Saddle and Lasso. New York:
F. Starr & Co., [1877]; Frederick Whittaker. *The Mustang-Hunters; or, The Beautiful
Amazon of the Hidden Valley. A Tale of the Staked Plains.* New York: Beadle and

Adams, [1862]; *Yeso, la strega del Colorado*. Firenze: Nerbini, 1923); **Slavic and Baltic Division:** 44 (acrylic on paper), 53; **Spencer Collection:** 40, 41 (published by Les societaires de l'Académie des Beaux Livres, Bibliophiles Contemporains)

New York Public Library Archives

11, 12 (lantern slide photographs of John Jacob Astor and James Lenox; photograph of Samuel J. Tilden by W. Kurtz), 13 (clipping), 14, 18, 21, 24, 25 (cartoon), 33, 49 (photograph by Laura V. Schnarendorf), 62 (lantern slide photograph), 63, 65 (lantern slide photograph), 70, 72 (both photographs; top photograph by Gladys Collins), 73, 74 (top: photograph of blind girl's hands © Steve Shapiro/ Black Star; below: Peanuts Characters; Courtesy of Charles M. Schulz – © United Feature Syndicate 1952), 79 (Port Richmond Branch), 80 (photograph by Bob Leavitt), 82 (photograph by Laura V. Schnarendorf), 88 (lantern slide photograph), 91, back cover

The New York Public Library for the Performing Arts

Billy Rose Theatre Collection: 85 (photograph by Apeda, New York), 96; **Jerome Robbins Dance Division:** 97; **Music Division:** 78 ("Brother, Can You Spare a Dime?" Words by E.Y. "Yip" Harburg; Music by Jay Gorney. New York: Harms Incorporated, 1932), 95 (*La Damoiselle élue* published by Librairie de l'art independant); **Rodgers & Hammerstein Archives of Recorded Sound:** 94

Schomburg Center for Research in Black Culture

Art and Artifacts Division: 101; **Manuscripts, Archives and Rare Books Division:** 100 (Wheatley's *Poems*); **Photographs and Prints Division:** 48, 99 (inscribed by Waters: "To Jerry / The Greatest Pal / I love sincerely / Ethel Waters"), 100 (Niagara Movement founders), 103

Science, Industry and Business Library

22, 127 (*Revue de l'énergie*, June 1997, published by Éditions techniques et économiques, Paris)

Photography credits

© Peter Aaron/ESTO: 4, 9, 113, 116 (below), 118, 128, 129 (above), 137; Adam Bartos: 117; Jennifer Bertrand: 26 (below left); © Anne Day: 50; © Walter Dufresne: 2–3; Lisa Garcia: 122 (below); David M. Grossman: 115; Don Hamerman: 71, 126: Tina Hoerenz: 98, 122 (above); Peter Peirce: 52, 87; Don Pollard: front cover, 26 (above), 114, 123; Marc Reeves: 111; James Rudnick: 133–35, 138; Manu Sassoonian: 100 (below), 101; © Tats, NYC: 129 (below)

Museum of the City of New York

25 (photograph of Andrew Carnegie by Davis & Sanford)

INDEX

Numbers in **boldface** refer to illustrations.

Allen, Frederick Lewis, 106

Anderson, Edwin Hatfield, 32, 33, 34

Andrew Heiskell Library for the Blind and Physically Handicapped, **74**, 75, 119, **122**

Arents, George, 105

Astor, Brooke Russell, **114**, 114–15, 132

Astor, John Jacob, 11, **12**

Astor, Vincent, 114

Astor Library, 11, 12, 13, 14, 15, 17, 29, **33**, 44, 114

Avery, Samuel P., **46**

Baker, Augusta, 72, **73**

Beals, Ralph A., 86

Belpré, Pura, **88**, 89

Berg, Albert A. and Henry W., 58–59

Bibliothèque nationale de France, 15, 31, 108, 138

Billings, John Shaw, **14**, 15, 21, 23, 29, 31, 32, 38

Blass, Bill, 131–32

Board of Trustees, 15, 19, 86, 103, 114, 136–37

Bostwick, Arthur E., 28–29, 61

Braille Book Review, 75

The Branch Libraries [Circulation Department], 23, **26–27**, 60–83; *catalog of:* LEO (Library Entrance Online), 127, 137; *programs and services:* Adopt-A-Branch, 119, 122; Centers for Reading and Writing, 123; Central Circulation, 29, 99, 116; Children's Services, 70, 72–73; Connecting Libraries

and Schools Project (CLASP), 122; Early Childhood Resource and Information Center (ECRIC), 122–23; Ethnic Heritage Centers, 123; Extension Division, 79; Office of Young Adult Services, **91**. *See also* Andrew Heiskell Library for the Blind and Physically Handicapped; Donnell Library Center; Mid-Manhattan Library; Neighborhood libraries; The New York Public Library for the Performing Arts; Science, Industry and Business Library

British Museum Library, 15, 31, 51, 108

Brooklyn Public Library, 25, 28

Bryant Park, 19, 118; Open-Air Reading Room, **80**, 81

Bryant Park Stack Extension, 118, **119**, 126

Butler, Samuel C., 119, 136

Carnegie, Andrew, 24, 25, **25**, 26, 86

Carrère, John Merven, 20, 79

Carrère & Hastings, 19–20

CATNYP. *See under* The Research Libraries

Cavaglieri, Giorgio, 86

Centennial of The New York Public Library, 124–26

Cogswell, Joseph Green, 11

Couper, Richard, 114

Cullen, Countee, 51

Cullman, Dorothy and Lewis, 132

Davis Brody Bond, 134

Deutsch, Babette, 36–37

DeWitt Wallace–Reader's Digest Fund, 122

Didion, Joan (quotation), 133

Digital Library Collections, 137–38; Digital Schomburg, 137

Donnell Library Center, 66, 68–69, 71, **72**, **89**, 89–90, **90**, 92, 123, 124; Central Children's Room, 29, 66, 68–69, 70, 71; Media Center, 90, 124; World Languages Collection, 92, 123

Evans, Walker, 76

Farm Security Administration, 76

Flexner, Jennie, 81

Ford Foundation, 106

Freehafer, Edward G., 32 (quotation), 109–10

Gay, Peter, 132

"Global Library Strategies for the 21st Century" (conference), 124, 126

Goldberger, Paul, 132

Gordan, John D., 59

Gregorian, Vartan, 115, 118

Gwathmey Siegel & Associates, 126, 128

Haas, Richard, 50

Harburg, E. Y. "Yip" (quotation), 78

Hastings, Thomas, 20, 29, 79
Healy, Timothy, 64, 118–19, 124
Heiskell, Andrew, 115, 118
Henderson, James Wood, 107–9
Hine, Lewis W., 74–75, 76
Hiss, Anthony (quotation), 83
Hopper, Franklin F., 64
Howard, John Tasker, 43
Humanities and Social Sciences Library, **11**, 14, **18**, **21**, **22**, **35**, **113**, **117**, **126**, 131, 132; *divisions of:* Arents Tobacco Collection, 38, 105, 107; Art and Architecture Collection, 39; Barbara Goldsmith Preservation Division, 109, **111**; Carl H. Pforzheimer Collection of Shelley and His Circle, 120; Dorot Jewish Division, 44, 48, 52; Economics Division, 38–39, 54; General Research Division, 34; Henry W. and Albert A. Berg Collection of English and American Literature, 58–59, 106, 121, 136; Irma and Paul Milstein Division of United States History, Local History and Genealogy, 130; Manuscripts and Archives Division, 104, 105, 136; Map Division, 45, 57; Miriam and Ira D. Wallach Division of Art, Prints and Photographs, 42, 46, 76; Oriental Division, 43, 44, 136; Photography Collection, 42; Print Collection, 46–47; Rare Books Division, 16, 31; Slavic and Baltic [Slavonic] Division, 36, **44**, 48, 53, 136; Spencer Collection, 40–41, 58, 136; *exhibition galleries and public spaces:* Celeste Bartos Forum, 116, **116**; D. Samuel and Jeane H. Gottesman Exhibition Hall, 115–16; Edna Barnes Salomon Room, 116; McGraw Rotunda, 116, **117**; *reading rooms:* Bill Blass Public Catalog Room, **108**, 116, 131–32; Brooke Russell Astor Reading Room for Rare Books and Manuscripts, 118, **118**; Deborah, Jonathan F. P., Samuel Priest, and Adam Raphael Rose Main Reading Room, 131–32, **133**, **134–35**, **137**; DeWitt Wallace Periodical Room, **50**, 54, 116; *facilities for scholars and writers:* Center for Scholars and Writers, 132; Frederick Lewis Allen Room, 106; Wertheim Study, 106
Huxtable, Ada Louise (quotation), 86

Javitz, Romana, 76
Johnston, Esther, 67

Kazin, Alfred (quotation), 132
Koch, Edward I., 113–14

LaGuardia, Fiorello F., 59
Laning, Edward, 55, 116
LeClerc, Paul, 124, 134, 137
Lenin, V. I. (quotation), 29
Lenox, James, 12, **12**
Lenox Library, 12, 14, 15, 17, 29
LEO. *See under* The Branch Libraries
Library of Congress, 13, 20, 31, 34, 43, 46, 51, 108
Lions sculptures, 23
Lydenberg, Harry Miller, 32, 33, **33**, 36–37, 51

McGraw, Harold W., Jr., 116
McKim, Mead & White, 20
Mid-Manhattan Library, **98**, 98–99, 115, 127; Picture Collection, 76, 77, 81, 83, 99
Moore, Anne Carroll, **70**, 70–71, 74–75

Morrison, Toni, 113
Mumford, Lewis, 90

Neighborhood libraries: Aguilar Branch, 124; Chatham Square Branch, **24**, **61**; Countee Cullen Branch, 51, 88, 102; Fordham Library Center, 81; George Bruce Branch, **72**; Jefferson Market Regional Branch, **27**, 86, **87**, 88; Morrisania Branch, 122; 115th Street Branch, **26**; 135th Street Branch, **49**, 51; Ottendorfer Branch, **26**, **82**, 83; Port Richmond Branch, **79**; Seward Park Branch, **63**, 67; Tompkins Square Branch, 65; West Farms Branch, **122**; Yorkville Branch, **26**, 28. *See also* Andrew Heiskell Library for the Blind and Physically Handicapped; The Branch Libraries; Donnell Library Center; Mid-Manhattan Library; The New York Public Library for the Performing Arts; Science, Industry and Business Library
New York City Landmarks Preservation Commission, 22–23
New York Free Circulating Library, 23, **24**, 25, 28
The New York Public Library for the Performing Arts, 43, 76, 91, 93–98, **93**, 114, 131, 132, 136; Billy Rose Theatre Collection, 93, 96; Dorothy and Lewis B. Cullman Center, 132; 58th Street Music Library, as predecessor of, 76, 81, 83; Jerome Robbins Dance Division, 93, 97; Music Division, 43, 76, 95; Rodgers & Hammerstein Archives of Recorded Sound, 93, 94

The New York Times, 13, 86, 114, 131
The New Yorker, 26, 83, 90
NYPL Express Information Services, 131

Oswald, Genevieve, 93

Panizzi, Anthony, 15
Parks, Gordon (quotation), 102
Polshak and Partners, 132
Potter, Edward Clark, 23

Queens Borough Public Library, 25

Reader's Digest, 50, 54, 122
Reddick, Lawrence, **49**
Remnick, David (quotation), 136
The Research Libraries [Reference Department], 23, 30–59; *catalogs:* CAT-NYP (CATalog of The New York Public Library), 107, 116, 127, 137; *Dictionary Catalog of The Research Libraries of The New York Public Library, 1911–1971,* 108, 137. *See also* Humanities and Social Sciences Library; The New York Public Library for the Performing Arts; Schomburg Center for Research in Black Culture; Science, Industry and Business Library
Robbins, Jerome, 93
Rohatyn, Elizabeth, 136
Rose, Ernestine, 51
Rose, Frederick Phineas, 131
Rose, Marshall, 119, 126, 136
Rose, Sandra Priest, 131

Salomon, Richard B., 115
Sayers, Frances Clarke, 74
Schiff, Jacob, 48
Schomburg, Arturo Alfonso, **48**, 51
Schomburg Center for Research in Black Culture, **48**, 49, **49**, 88, 99–102, 103, 115, **116**, 131, 136; Digital Schomburg, 137; Langston Hughes Lobby, **116**; Manuscripts, Archives and Rare Books Division, 99; Oral History/Video Documentation Project, 102; Photographs and Prints Division, 99, 103
Science, Industry and Business Library (SIBL), 126–27, **128–29**, 131, 136; Elizabeth and Felix Rohatyn Electronic Information Center, 127; Electronic Training Center, 127; Healy Hall, **128**, **129**; International Trade Resources Center, 127; Richard B. Salomon Research Reading Room, **129**; Small Business Information Service, 127
Second Century Campaign, 136–37
Spencer, William Augustus, 40
Stryker, Roy, 76
Szladits, Lola L., 59

Taft, William Howard, 21
Tilden, Samuel J., **12**, 14, 15
Tilden Trust, 14, 15

Vaux, Calvert, 27
Vincent Astor Foundation, 114

Wallace, DeWitt, 50, 54
Wallace, Lila Acheson, 54
Wilmerding, Lucius, 105
Withers, Frederick Clark, 27
Wolfe, George C. (quotation), 98
Works Progress Administration (WPA), 55, 56, 81, 116
World Wide Web site, 133, 137

Yarmolinsky, Avrahm, 36–37, **36**, 48
Young, Owen D., 59